MARTHA'S VINEYARD
THROUGH TIME
Tourism and the Cleansing Sea

D0808104

A. C. THEOKAS

AMERICA
THROUGH TIME®
ADDING COLOR TO AMERICAN HISTORY

America Through Time is an imprint of Fonthill Media LLC
www.through-time.com
office@through-time.com

Published by Arcadia Publishing by arrangement with Fonthill Media LLC
For all general information, please contact Arcadia Publishing:
Telephone: 843-853-2070
Fax: 843-853-0044
E-mail: sales@arcadiapublishing.com
For customer service and orders:
Toll-Free 1-888-313-2665

www.arcadiapublishing.com

First published 2021

Copyright © A. C. Theokas 2021

ISBN 978-1-63499-342-5

Typeset in Mrs Eaves XL Serif Narrow
Printed and bound in England

FOREWORD

The scope of this book may be island wide, but Oak Bluffs predominates. The reason is simple. The first waves of summer vacationers came to Oak Bluffs, not Martha's Vineyard. Vineyard Haven eventually became a tourist destination, but the 1883 fire that destroyed the entire business district was a major setback. Edgartown, reluctant to adulterate its Greek revival ambience, finally solicited a more preferred grade of summer visitors with the opening of the high-end Harbor View in 1891. Yet it was too little, too late—Oak Bluffs had stolen the show.

This book's format consists of the pairing of photographs, vintage with contemporary. Each contemporary image restages, as closely as possible, the original photographer's perspective and position and is not intended to stand on its own. It is this pairing of images, separated in time, that reveals the scope of change. There have been many changes, but there is also one constant; the motivation of those who return summer after summer.

Are we so different from those first visitors of well over a century ago? We have all had that moment when we wished for the sun not to drop, or the day not to end or autumn to wait. It is a moment imagined where everything stays the same, where there is no substance or consequence, where there is only idealized motion through an idealized scene. Martha's Vineyard stirs a nostalgia for past happiness. Those who return do so with the coveted certainty that the island has changed but little. Like the vacationers in *M. Hulot's Holiday*, as described by Ebert, they come for "the simplest of human pleasures: the desire to get away for a few days, to play instead of work, to breathe in the sea air, and maybe meet someone nice. It is about the hope that underlies all vacations and the sadness that ends them."

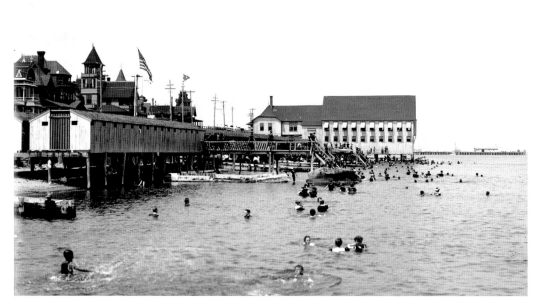

Above is the beach at Oak Bluffs, about 1890, with bathhouses and the café that once existed out over the water. Below is a 1930 postcard published by the New Bedford, Martha's Vineyard and Nantucket Steamboat Company showing Oak Bluffs as the 'center' of Martha's Vineyard with distances to other Island locations measured from it. (*loc, mvm*)

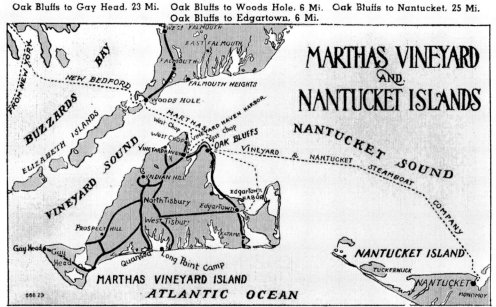

There is no stranger social organism than a summer resort.

Henry Beetle Hough

The very fact of taking a boat, and finding a place indifferent to mainland ways, gives the travelers to the Vineyard a sense of having come far on a pilgrimage to a uniquely peaceful and picturesque spot ... a refuge after a storm.

Joseph C. Allen

I really don't know why it is that all of us are so committed to the sea, except I think it's because in addition to the fact that the sea changes, and the light changes, and ships change, it's because we all came from the sea. And it is an interesting biological fact that all of us have in our veins the exact same percentage of salt in our blood, in our sweat, in our tears. We are tied to the ocean. And when we go back to the sea—whether it is to sail or to watch it—we are going back from whence we came.

President John F. Kennedy

Introduction

Each summer, Martha's Vineyard is the destination of an exodus akin to the flight from Egypt. However, it is not the Red Sea that is crossed, but Vineyard Sound. By the end of the season, over 500,000 make this journey to experience life on an island whose distance from the mainland is more psychological than physical. Vehicles packed with brightly colored beach umbrellas, plastic pails and shovels, folding chairs and fat novels roll off ferries and head for a shoreline setting with the calming cadence of breaking waves. More than just a day at the beach, it is also a long-evolved practice that has shaped this island's life and character.

A 1987 summer visitor, frustrated with the lack of information from the Steamship Authority, decided to row across Vineyard Sound. Nautical charts show the distance

from Woods Hole to the closest point on the island as just over 3 miles. In the end, D. C. Denison safely made it, but the rest of us will still opt for something larger than his 10-foot dinghy. Dependency on ferry travel can at times frustrate, but the idea of a bridge across the sound will never be proposed. The fact that Martha's Vineyard is an island is the whole point.

The first ferries to run scheduled services were all sidewheelers until the *Sankaty*. The first propeller driven boat, she began a run in 1911 that lasted thirteen years. Later boats such as the *Uncatena*, *Nobska*, or *Naushon* also had names with an air of romance. The *Gay Head* that brought tourists from Oak Bluffs for their day's excursion to the Gay Head light had a "social hall" finished with black walnut and maple wainscoting, ornate gold trim, and cherry wood seats with velvet upholstery. The first *Islander* had small staterooms for passengers preferring privacy. The last steam powered vessel, the *Nantucket,* made her final run in 1987. The name "Steamship Authority" is now a misnomer as the vessels are no longer steam-powered. An iconic characteristic of these boats was their whistles, each with an identifying tone. Later diesel-powered boats were at first mute, but due to the efforts of supporters of island traditions, boats now use original whistles powered by compressed air instead of steam. If you should ever travel on *The Eagle* to Nantucket, know that as her whistle sounds, it is the *Nobska* you hear.

Of all the boats to have served the Vineyard, the second *Islander* was the most popular. Running for fifty-seven years beginning in 1950, she began, and ended, the vacations of countless thousands. Her familiar rounded bow with its black spear paintwork was a welcome, even reassuring, sight as she came around the headland. It was thought she would sail forever and her eventual retirement was an unwelcome change. Her replacement vessel, the *Island Home*, has some years of service yet before achieving such status. Boats plying the sound have come and gone over the years, but their passengers still come, as they always have, for that day at the beach.

The idea of the sea as a place of therapy and recreation came about only relatively recently in the long history of public life. Earlier concepts of the sea were biblical, mythic. The sea was a mysterious, rolling expanse harboring serpents deep in its murky depths. A belief in its perils gradually gave way to supposed medicinal qualities. Therapeutic soakings were touted as a remedial harmony between the body and the sea. Bathing in it could heal rickets, restore the complexions of chlorotic girls, give hope to barren woman, and treat impotence or any number of ailments. Immersion was a tonic offering bracing coolness, saltiness, and the physical delight in feeling the forces of a powerful ocean. The energy of buffeting waves stirred a peculiar fascination with the sensation that one could be swept away at any moment. The lure of the seaside swelled and spread.

Like so many other things, the seaside vacation became one of Britain's cultural exports. Coastal resorts multiplied, and by the late nineteenth century, they reached New England at a time when a growing middle class sought an escape from sunbaked manure and mundane modernity. The seaside became a destination hinting of a new freshness. Coastal communities once ignored were now "quaint" and underwent closer scrutiny. A novel social scene developed, and competition grew between emerging resorts.

Martha's Vineyard, though, had a major advantage over all the others. Before it was ever a summer resort, it was already a seasonal destination. These first repeat summer visitors, however, did not come for the sun and sea. They came for solace and salvation.

Methodist revivals played a significant role in the religious life of frontier America, converting thousands with their emotional, fervent brand of Christianity. One of the most successful of these was on Martha's Vineyard. Local Methodists selected an area of barren ground to hold their meetings and named it Wesleyan Grove. Its growth was dramatic with weeklong August revivals attracting thousands. Over the years, pilgrims began to arrive earlier and stay longer. Communal tents gave way to private ones and, finally, individual cottages. Its popularity grew and in 1865 was featured in a *New York Times* travel article. The "Campgrounds" was also written up in a *Harper's Weekly* of 1868, describing activities typically enjoyed on a seaside holiday:

> These thousands of people who frequent Martha's Vineyard at this season have more and fresher pleasures than those who summer at Newport or Long Branch. Here you see the latest fashions, and innocent flirtation is not unknown among the lads and lassies. They play croquet. Just below the steamboat landing there is a beach for bathing. And then there is fishing and sailing for those who are fond of aquatic sports, several good sail boats being always at anchor off the pier.

Martha's Vineyard had unintentionally become a resort.

Newly arriving camp members were now thought of as potential customers by the more entrepreneurially minded of the Campground community. Chief among these was Erastus Carpenter, who made his fortune in the manufacture of straw hats. With others, he established the Oak Bluffs Land and Wharf Company and purchased the farmland directly adjacent to the Campground. A landscape gardener, Robert Morris Copeland, was enlisted to create a masterplan to attune space with desire. Advertisements soon appeared for lot sales in this "new summer resort," and by 1871 Cottage City was ready for occupancy. It was the first town in America designed exclusively for tourism.

The Campground remained in operation, continuing to attract thousands seeking deliverance. Proximity with this religious community influenced the business practices of the Wharf Company. In consideration of the adjacent Campground regulations, it sold property lots only to families. Moreover, certain businesses such as liquor establishments or gambling halls were prohibited and ferry service was suspended on the Sabbath. This suppression of suspected "immoral pleasures" did not, however, deter summer visitors—it attracted them. Those who first purchased cottages here may not have followed the strict daily schedule of the nearby Campgrounds, but they still preferred Cottage City to the "heedless behavior" found at other resorts. Martha's Vineyard was not only a popular resort, it was a different one. Other resorts touted the sensual pleasures of the seaside, but Oak Bluffs was safer. The Campground influenced the early character of tourism here and it is even arguable that without camp meetings there might not have been any Oak Bluffs at all.

The subsequent construction of several large hotels gave the town its resort-like feel. Nothing accomplished this more than the Sea View House. Opening in 1872 at a cost of $2.5 million in today's money, it set a standard. Situated at the head of the wharf, it dominated the waterfront with a length of over three hundred feet and a broad seaside terrace. At five stories high, it offered a view of the Elizabeth Islands, the mainland across the sound, and the Vineyard itself. It had a barbershop, steam powered elevator and dining room for 400. Heated, gas-lit, plastered rooms had "speaking tubes" connecting them with the front desk. Its architectural style was unique to the island—an allusion to fairytale fancies inspiring visitors to indulge their own. The Sea View House declared itself the exceptional resort experience.

The commercial success of early Oak Bluffs inspired its duplication elsewhere. The first attempt at this was a development on the southeast part of the island known as Katama. The Katama Land Company was formed and acquired 600 acres of land along Katama Bay and South Beach. Soon after, in 1873, the Mattakeesit Lodge opened. It was intended as the initial stage of a much larger development consisting of surrounding lots to create a community of hundreds of summer cottages. A 250-room hotel to surpass even the Sea View House in scale and grandeur was to follow. The main attraction here, however, was not the architecture, but the drama of South Beach. As popular as Oak Bluffs was, its tame shoreline could not compete with a beach where one could witness "mountainous wave crests, many miles in width, topple and fall with a noise like thunder," as one early chronicler wrote. The aim of the Katama Wharf Company was not only to commodify island landscape, but South Beach as well. It may not have been possible to carve up the shoreline into parcels, but a market for its scenery was attempted, nonetheless.

This new business venture, however, soon struggled. In its first year, only twelve lots were sold. The Mattakeesit Lodge was difficult to reach and felt remote once there. In a desperate move to improve business, a railroad was built to transport tourists to the lodge directly from Oak Bluffs. The Old Colony Railroad had already laid track terminating at the Woods Hole wharf. Why not have passengers continue their rail journey onward from the Oak Bluffs wharf? A vote at an Edgartown town meeting led to the financing of the Martha's Vineyard Railroad (MVRR). Track was laid linking Oak Bluffs to Edgartown and from there out to Katama and the Mattakeesit Lodge. From the start, this was an ill-considered project. Building a railroad along a sandy coastline was imprudent enough, but pressure to complete the line before the end of that first summer season rushed construction. Continuous and costly repairs to the track that was washed out in winter storms ate into the railroad's meager revenue, and maintenance problems plagued it throughout its entire twenty-year existence.

The MVRR closed operations in 1894, but that did not end island rail travel. The Oak Bluffs Street Railway operated horse-drawn trolleys, running from the wharf at Oak Bluffs to the Campgrounds. There was also another wharf in the Highlands section of Oak Bluffs to serve those arriving for Campground meetings. A trolley ran from that wharf along what is now East Chop Drive straight into the Campgrounds, enabling arriving congregants to avoid Oak Bluffs distractions altogether. Subsequent to the horse-drawn trolley came the

electric trolley running from Oak Bluffs to Vineyard Haven. Beginning in 1895, it was an overwhelming success. Passengers rode this from Oak Bluffs along New York Avenue to Beach Road ending at the wharf in Vineyard Haven. The trolley system lasted until 1918, when automobiles and jitneys finally became the dominant mode of island transportation.

The Panic of 1873 lasted five years and affected all areas of the economy, including tourism. The Katama development became a losing proposition and ultimately failed. The summer cottage lots were sold to buyers who saw them only as a resale investment in a down market and not a single cottage was ever built, nor was the 250-room flagship hotel, and after years of languishing sales, Mattakeesit Lodge closed. The weak market also affected the famed Sea View House and it burned to the ground in a fire of suspicious origin in 1892. The fire not only destroyed the hotel, but also the wharf gateway and nearby casino. Arriving ferry passengers now saw only lingering ash heaps, prompting one reporter to write that "tourists may travel to Rome to see ruins, but not here".

Edgartown finally entered the tourist business in 1891 with the opening of the high-end Harbor View Hotel. It offered a decent prospect of the outer harbor and Cape Pogue, but had no nearby park, beaches, dance halls, or the animation of arriving steamboats. No matter as this was what its backers wanted—a nice, quiet, respectable place. It sought to attract a better class of clientele than did Oak Bluffs and it succeeded.

The towns were developing, but the up-island journey remained arduous. Still, there were profits to be made in bringing tourists to the Gay Head light and colorful clay cliffs. Steamboat excursions from Oak Bluffs to Gay Head were the solution. A 300-foot wharf, the subject of many photographs, was constructed in Gay Head, and after arriving, sightseers rode on oxcarts up to the lighthouse. Early accounts of a typical excursion reveal a mixture of the simple and sublime.:

> After a ride to the top of the cliffs in an oxcart wagon, we arrived at a pavilion where a band played, and light refreshments made available. Other establishments owned and operated by the Wampanoags offer a more substantial fare.

Another early visitor wrote:

> The most patronized eating place was Leonard Vanderhoop's on the cliff near the light. it was cool there and the view was perfect ... one could buy a dinner for fifty cents of fish or clam chowder, lobster and blueberry pie. All the fish were caught fresh and the berries grew nearby.

Not everyone welcomed this new enterprise. The *Cottage City Star* lamented that these excursions prophesied the end of Gay Head:

> A feeling of sadness came over the thoughtful mind as it reflected what the possibilities of the changes which the introduction of this little pier may bring to primitive people ... and once civilization set her hand at work, it suggests a crowding and supplanting of the native-colored people, now monarchs of this beautiful little promontory on the Vineyard.

The writer went on to comment that he feared Gay Head would go the way of England's Isle of Wight, despoiled as it was by "big hotels and numerous elegant villas." Improved roads and the increasing presence of the automobile led to the end of these excursions in 1915, and the wharf was left to decay. Despite his early prediction, the Gay Head light promontory remains unspoiled, and the remaining modest commercial activity is still managed by the Wampanoags.

Early summer visitors to Martha's Vineyard enjoyed dancing, sailing, cycling, tennis, and baseball. The one physical activity pursued with less of an understanding of its practice was, ironically, swimming. Until this time, women were never seen in public wearing anything other than clothing that both hid their form and expressed social rank. Accordingly, the first bathing suits were ensembles covering the entire body, including stockings and special purpose shoes to avoid the erotic charge of a bare leg and foot (see cover photo). The most fashionable style employed a nautical theme with sailor collars and were made of wool or cotton. A Boston store listed the price of a "blue flannel bathing suit trimmed with white braid" as $3, or about $90 in today's purchasing power. These were not made for serious swimming but wading or simply standing in chest deep water and chatting. Walking through town wearing these bathing costumes was frowned upon, "decent" as they may have been. As this custom was too often flouted, a town ordinance was passed in 1905 forbidding anyone to be seen anywhere in bathing attire except on the beach. Nearly 700 bathhouses were constructed by the turn of the century to solve this problem, giving the Oak Bluffs beach its early character.

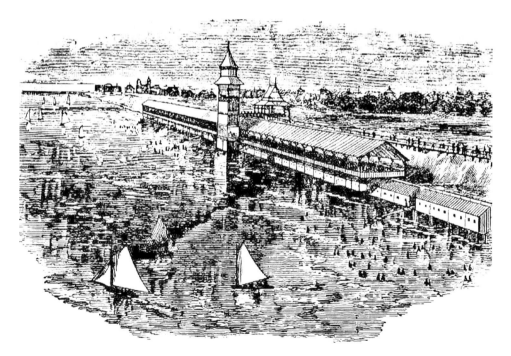

Figure 1: Early sketch of proposed seaside construction along the beach at Oak Bluffs.

Bathhouses can be magnificent examples of civic architecture. Here, however, they were built more out of a social need and less as a design statement. They were cheek-by-jowl, tiny changing rooms with a daily use fee of ten cents. Once inside, the only light available came through a small rectangular opening high up on the outside wall. Roughhewn as these were, they may have been the first stage of a larger design vision. Figure 1 is from Reid's Sea Side Souvenir, published in 1883. It depicts a complex that never existed as shown. The bathing tower, bathhouses, and small pagoda were built, but not the roofed terrace built over the bathhouses. It was a vision never realized.

Despite the fact these early bathing costumes were decent enough they still met with opposition, some of it rather peculiar. An editor for the *Island Review*, an early seasonal newspaper, opined:

> A bath house is a great disenchanter, and in a moment or two, can scatter most thoroughly the fondest dream of beauty and remove the mask from face and form ... The beauty who has captivated the hearts of unmarried swains at the evening hop is by no means certain to prove a Venus as she rises from the merciless waves.

Bizarre comments such as this suggest agreement over of what constituted proper beach behavior was not widespread.

A structure a bit more upscale than the bathhouses was the octagon-shaped pagoda across from Ocean Park that served refreshments and provided access to the beach below. It was built along the plank boardwalk that replaced a crude seaside path. An observation or "bathing tower" was later built about halfway along the boardwalk. This half-mile-long "plank walk" may have encouraged strolling, but if seaside promenades were what was to be encouraged, one might wonder whether early stakeholders were aware of the tremendous popularity of British pleasure piers—the most iconic symbol of the British seaside holiday and the epitome of excursions to the coast. Constructed to boost the attraction of Victorian seaside resorts, they incorporated bandstands, cafes, and even music halls into their designs to meet the growing enthusiasm for pleasure-seeking by the seaside.

The most popular landmark on the beach at Oak Bluffs was not one of architecture, but nature. Lover's Rock was a massive boulder located just out from where the old Sea View Hotel once stood. It was what is known as a glacial erratic—a glacially deposited rock inconsistent with the type of rock native to the area in which it rests, evidence of the passing of a massive glacier. No other island location served as the setting for a group photo as much as Lover's Rock. How it acquired that name will perhaps never be known. What could have been more appropriate? The island was visited by thousands of young singles, mingling at the Tivoli and then pairing off for moonlit walks along the beach. Lover's Rock would likely have been a romantic stop for them, perhaps even the site of many a marriage proposal. It is still there but now below tons of sand. Its disappearance was not the result of any natural process but improvements to the narrow beach front in the 1970s. Too large to move, it was buried, along with a piece of the Island's social history. Why not here?

Oak Bluffs began as Cottage City, but it was under the civic administration of Edgartown until its "secession" in 1890. Finally, the name was officially changed to Oak Bluffs in 1907, having been in widespread use well before that. That year might well be considered the town's high-water mark as a resort when the *Martha's Vineyard Herald* wrote:

> We're in full swing. Everything going. Trolley cars, skating rink, dance hall, moving pictures, flying horses, fishing boating, automobiling, bicycling, driving, etc. Everybody come down and have a good time when it's too warm to stay in the city.

Early photographs show a main street lined with four-story hotels and souvenir shops selling exotica. A band located on the veranda of the Pawnee House played popular tunes, adding to the scenic and theatrical experience of strollers below. The Pawnee House and all other Circuit Avenue hotels are no longer. The simplest irony is that based on architecture alone, the nearby Campgrounds has a more worthy legacy of this phase of Island history than that of the town, steps away, it inadvertently caused.

Perhaps the destiny of Martha's Vineyard as a summer resort was written, but it is difficult to imagine how or when promoters would have come on the scene without the impulse of the Campground's success. The burst of tourism here in the late nineteenth century, as it had to, peaked and passed. The early twentieth century was anticlimactic. The change it brought was not so much in numbers but in social stratification. These "country club" years heralded the arrival of film stars, writers, and others who played tennis, golfed, and sailed. After a relatively dormant post-war period, the 1960s began a new resurgence in the attraction of Martha's Vineyard for the middle class. A Hollywood blockbuster was filmed on its beaches, and United States presidents licked locally made ice cream. More celebrities arrived along with the *noveau riche* to secure their Island bolt-holes.

"Ordinary" summer visitors, however, still come as they always have, to capture, or recapture, a personal Martha's Vineyard moment; the colorful clay cliffs, the historicity of the Old Whaling Church, the contemplative space of the Tabernacle, the spread of South Beach or a Menemsha sunset. Henry Beetle Hough may well have been right when he declared that "the Island has found its best interpreters in casual visitors, in the cultivated enthusiasm of amateurs, rather than the promoters and the enterprise of catchpenny writers."

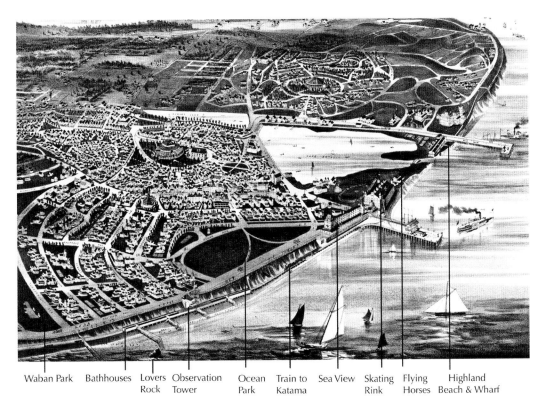

| Waban Park | Bathhouses | Lovers Rock | Observation Tower | Ocean Park | Train to Katama | Sea View | Skating Rink | Flying Horses | Highland Beach & Wharf |

COTTAGE CITY AND OAK BLUFFS: Above is a bird's eye view of Cottage City printed in 1890. Used not so much as wayfinding, prints such as this were primarily intended to show major sites, attract visitors, and stir up local pride. Landmarks were enhanced and an interplay of different scales was usually incorporated to provide easier recognition of key features. The top image is slightly edited through the labeling of landmarks. Lithography by Robert Welck. (*loc, dw*)

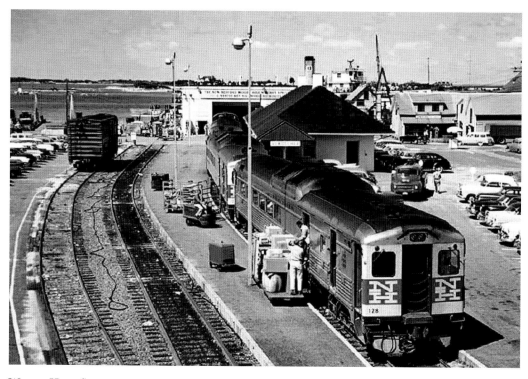

WOODS HOLE STATION: Operating as a railroad station for nearly eighty years, Woods Hole was once the terminus of the Old Colony Railroad line from Boston. The message on the back of a 1959 postcard reads, "It's good that you have planned to come here in mother's car as there are no trains to Woods Hole. They have been discontinued." The terminal shown in the top image has been razed. The site of the beginning, and ending, of countless Vineyard vacations, it is currently undergoing another renovation. C. 1957. (*Courtesy Chris Keniston*)

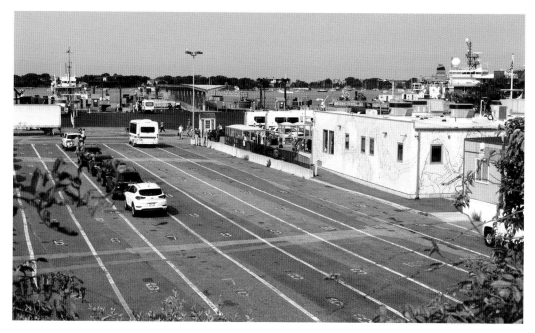

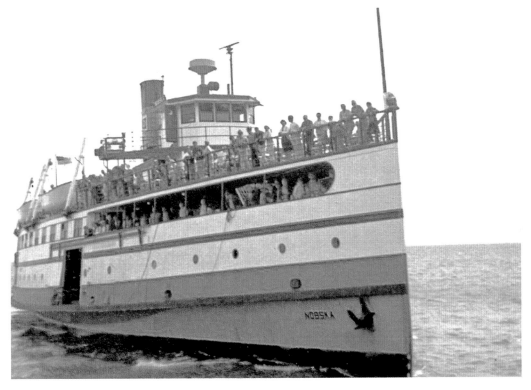

NOBSKA: The *Nobska*, launched in 1925, sailed for nearly a half century making its last crossing in 1973. This 1968 photo shows that she was not a "ro-ro" vessel where vehicles drove in one end and out the other. The last coastal steamer, she was eventually scrapped in 2006 despite efforts to save her. The replacement vessel, the *Nantucket*, first sailed in 1974 and served both Martha's Vineyard and Nantucket. Below, she is shown coming into Oak Bluffs. (*mvm*)

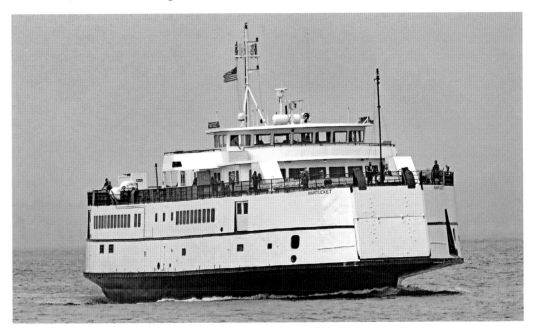

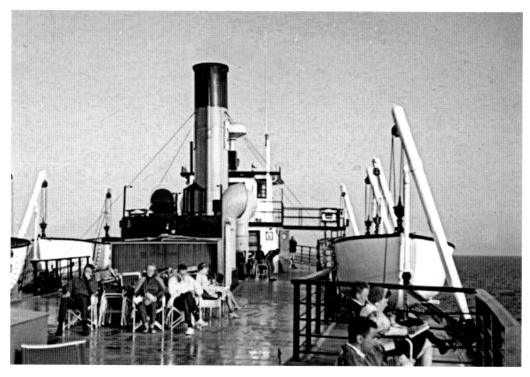

THE BOAT DECK: The term "boat deck" derives from the upper deck where lifeboats were once stored. Above, the deck of the *Nobska* is shown at a time when ferries still had lifeboats. Note the movable seating, allowing passengers to align their chairs with the sun or create a more sociable arrangement with fellow passengers. The bottom photo of the *Nantucket* that followed the *Nobska* shows how the ferries of today have regimented rows of seating, bolted to the deck. C. late 1960s. (*whe*)

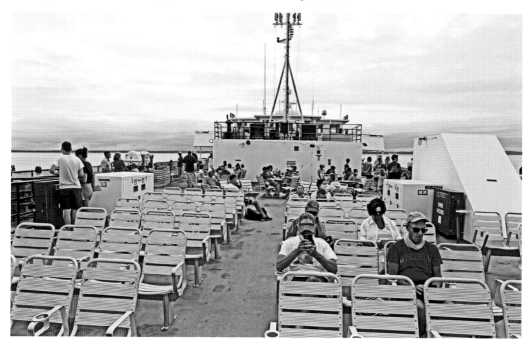

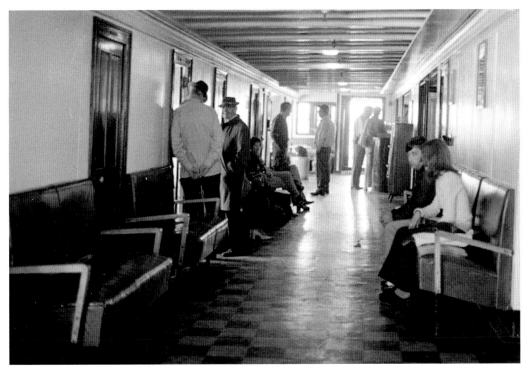

BELOW DECK: A main difference between the boats of today and those such as the *Nobska* shown above was the availability of staterooms. The crossing time may have been brief, but private "day parlors" were available for those wishing to avoid a crowded deck. The bottom photo is a below deck view of the contemporary boat, the *Island Home*. There is more seating, but staterooms are no longer an option. C. 1965. (*whe*)

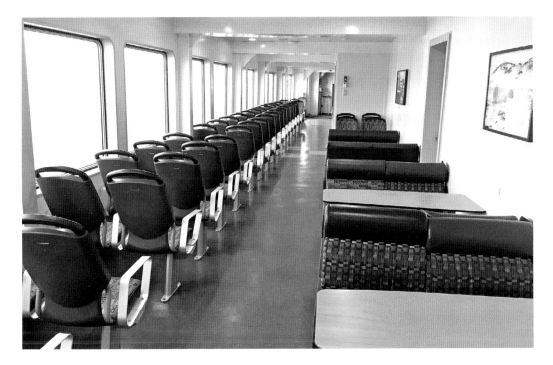

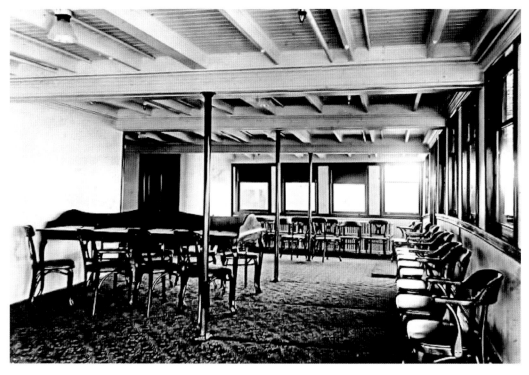

WRITING SALOONS: Once upon a time, if you wished to communicate with someone distant, you wrote in longhand. Here is a view of the writing area in the forward part of the saloon deck on an early vessel, the *Islander*, later renamed the *Martha's Vineyard* and launched in 1923. Ink, pens and paper with the steamship company's logo were supplied. The bottom photo is of the successor vessel, the *Nantucket*. Plenty of space to write, although this was more likely by keyboard than fountain pen. C. 1923. (*whe*)

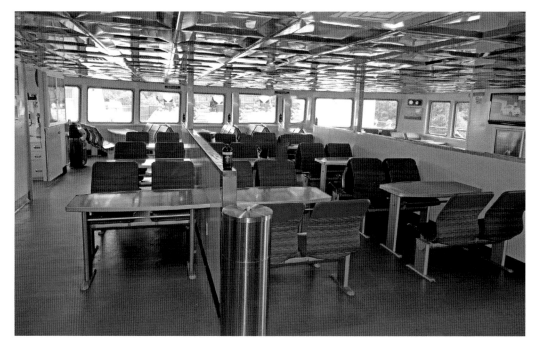

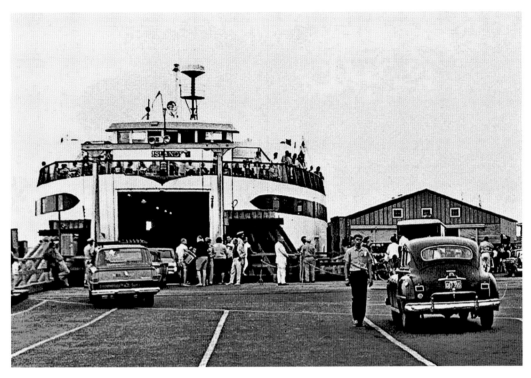

THE *ISLANDER:* No boat was more beloved. Beginning in 1950, the *Islander* was the first "drive through" boat and the first to carry trailer trucks or "semis" to the island. More grit than grace, she plied the sound for nearly sixty years before being retired in 2007, shattering her illusion of permanence. At summer's peak, she carried over 700 passengers and eighty-five vehicles. The *Island Home* that followed retained the *Islander's* iconic black hull bands. C. 1965. (*mvm*)

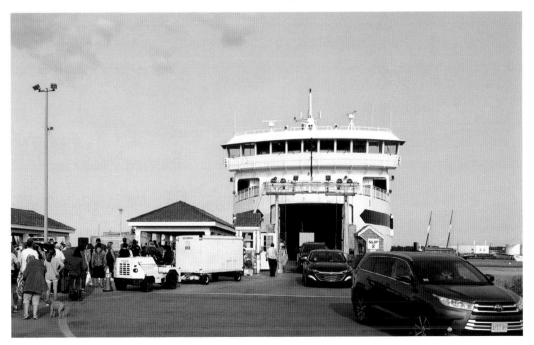

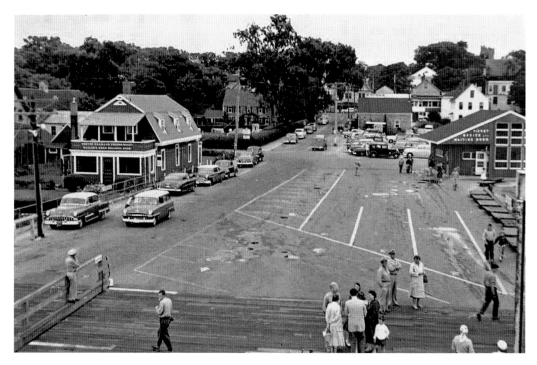

VINEYARD HAVEN TERMINAL: Signage on the opposite side of the "modern" building at right reads "New Bedford, Woods Hole, Martha's Vineyard and Nantucket Steamship Authority," thus dating the photo to after 1948, when the Steamship Authority was established. The gabled building at left was once the Seaman's Friends Society and is now the site of the present Vineyard Haven Steamship Authority ticket office. C. 1952. (*mvm*)

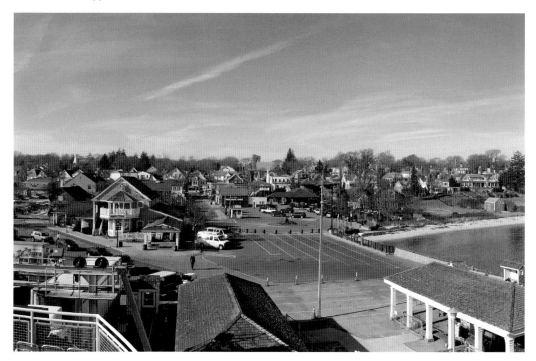

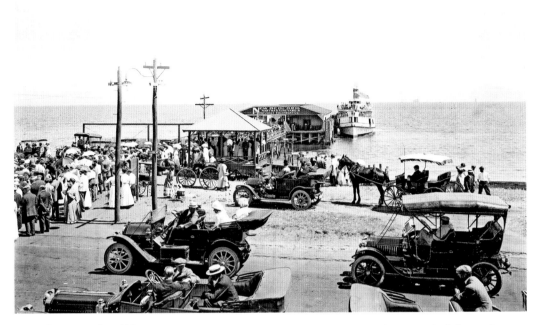

COTTAGE CITY WHARF: Shown is an early version of the Cottage City ferry terminal that underwent many changes in appearance. Docked is the *Sankaty*. Launched in 1911 she was the first propeller-driven steamer, thus ending the era of the old sidewheelers. Arriving passengers and those awaiting are shown. Everyone is turned out well in ties and stiff collars, but a growing relaxation of a woman's dress code is shown by a number without hats. C. 1912. (*hne*)

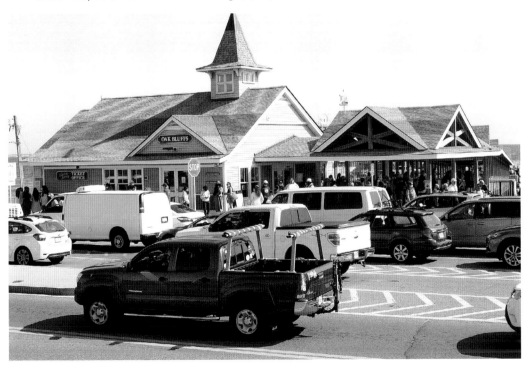

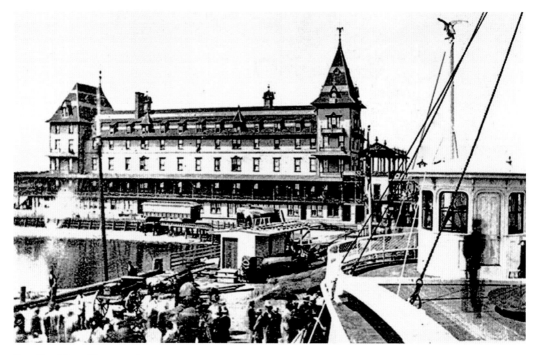

THE SEA VIEW HOUSE: The top image shows the striking view arriving ferry passengers had of the Sea View House, which opened in 1872. Note the rail car on the dock awaiting to load passengers for the run to Katama. The boat from which this photo was taken is the *River Queen*, which began service in 1871. Samuel Freeman Pratt designed the Sea View, an architect whose imprint is on much of early Oak Bluffs. The Sea View employed design elements of a style referred to as "European secular Gothic." C. 1875. (*mvm*)

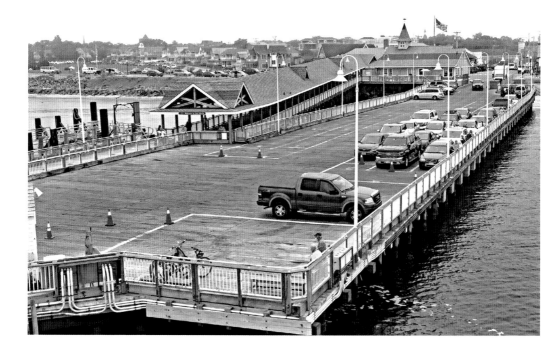

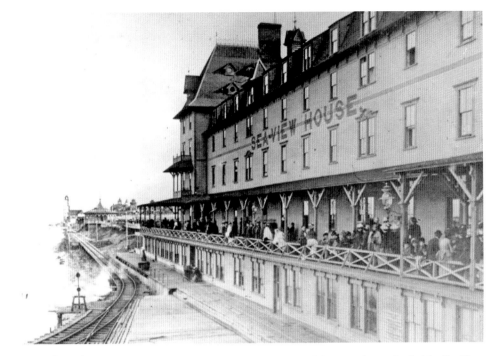

COTTAGE CITY ARRIVAL: The top image is the imposing view arriving vacationers had of the Sea View House just off the Cottage City wharf. The long terrace shown was a perfect spot from which to take tea while enjoying the changing scene of arriving boats and the view of the sound. Despite associations with lower-class establishments such as "boarding house" or "flop house," "house" was used to name hotels to encourage the sense of personal care. Further along, the Pagoda and Observation Tower can both just be seen. C. 1880. (*mvm*)

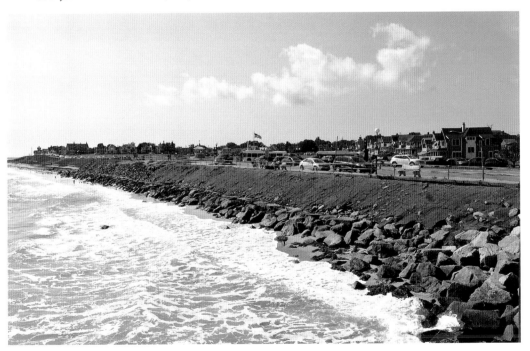

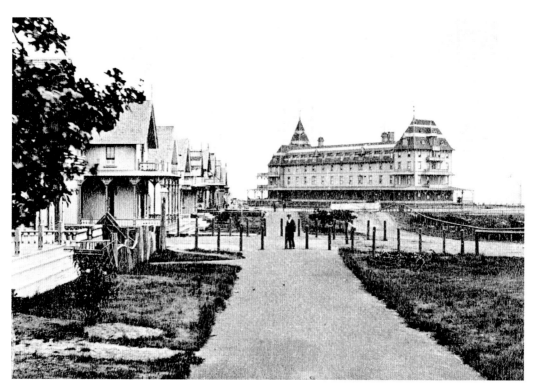

OCEAN PARK AND THE SEA VIEW: The tree at left is an unusual sight as the park's design prohibited them to allow for unobstructed views of the sea from cottages lining the edge of the park. The Sea View House dominates the view from this and many other perspectives. Taken before the era of the automobile, the bollards shown were used to control the movement of horse-drawn carriages. C. 1880. (*mvm*)

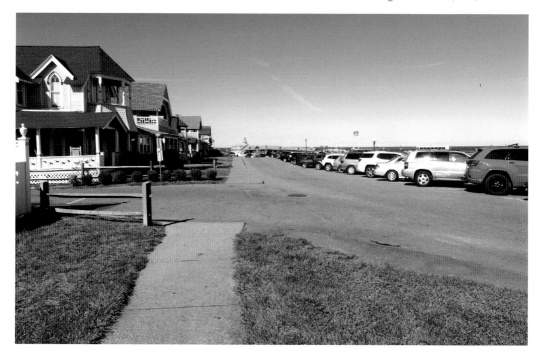

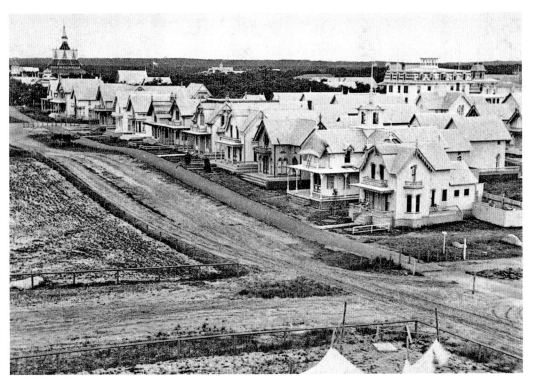

COTTAGE CITY AERIAL: Likely taken from atop the Sea View House, this early image of Cottage City recalls that adage of designers stating that "when finished, the architecture will never look better, and the landscape will never look worse." The beginnings of a "skyline" can be seen with the Pawnee House hotel at right while Pratt's Union Chapel is at left. Note Sea View sheets drying on the line in the lower foreground. C. 1880. (*mvm, dw*)

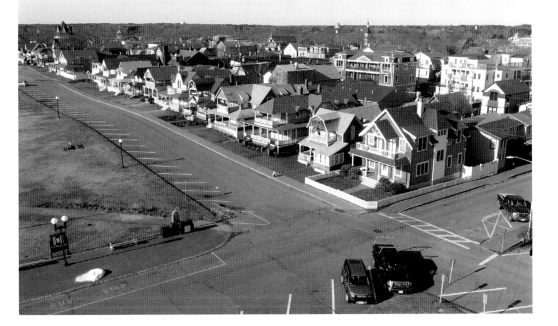

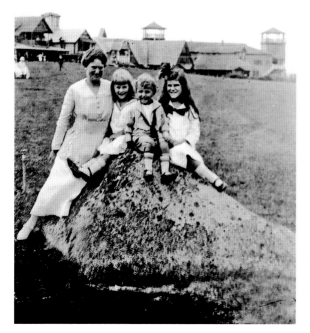

OCEAN PARK SITTINGS: Ocean Park is dotted with a few large boulders or "erratics" left by a retreating glacier. Here, one is used as a setting for family photos (seen *c.* 1910). The towers of the Tivoli dance hall can be seen in the top photo, thus situating it. An anonymous mother poses with her children dressed for a photograph, which was, at that time, a special event. In the bottom image are Sara with Oliver and Veronica, enjoying a casual day in the same location. C. 1910. (*mvm*)

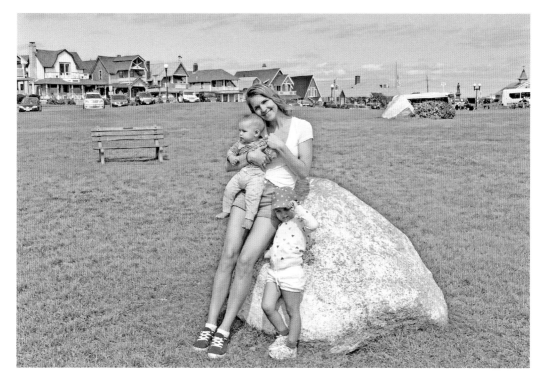

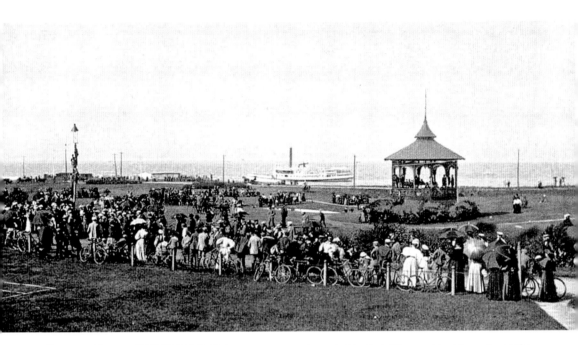

BICYCLE DAY IN OCEAN PARK: Not everyone came to early Martha's Vineyard just for a day at the beach. Shown above is "bicycle day" in Ocean Park. Cycle races were popular in the late nineteenth century and no less so on Martha's Vineyard with miles of paved roads. Cycling for pleasure or charity rides is still commonplace, but it is not so well-known how much its nineteenth century popularity empowered women or "velocopedestriennes," who could express physicality on a bicycle more than they could on a beach. C. 1890. (*mvm*)

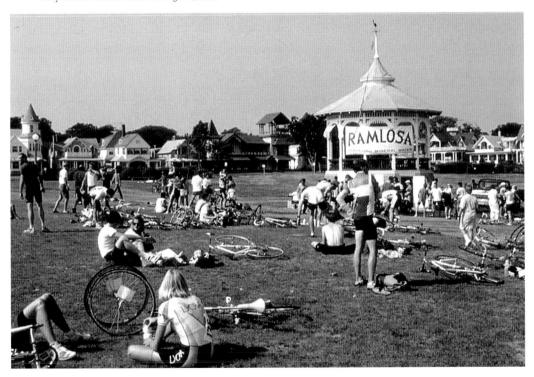

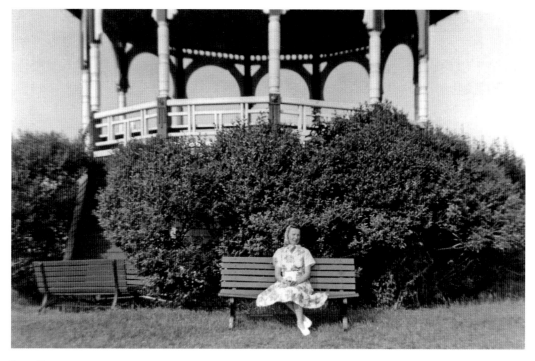

THE BANDSTAND: Referring to this as "The Gazebo" is like saying "Oaks Bluff" as it is not a gazebo, but "The Bandstand." A designed open space must have a focal point. This one, constructed in 1887, is Ocean Park's. It is also symbolic of community and a protected landmark. Oompah bands play here on summer evenings, spilling live music out over the park while children skip around the base. It has undergone minor alterations over the years, but still retains its classic profile. 1941. (*courtesy M. Knasas*)

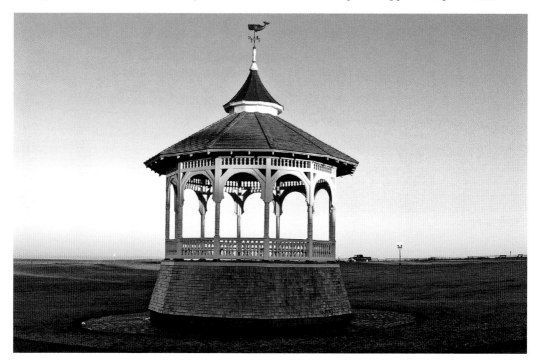

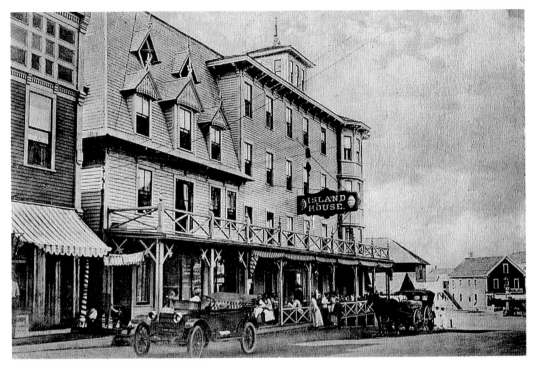

THE ISLAND HOUSE: "A favorite hotel for those who visit the Island on business," declared an early advertisement for this four-story building at the head of Circuit Avenue. Long verandas such as shown were integral to the design of this and other hotels. A later chronicler wrote, "I don't know whether people got less friendly and therefore hotels took down their porches, or whether they took down their porches and then people got less friendly. In any event, the porches on Circuit Avenue greatly added to the ambiance and friendliness that obtained in those days." C. 1910. (*mvm*)

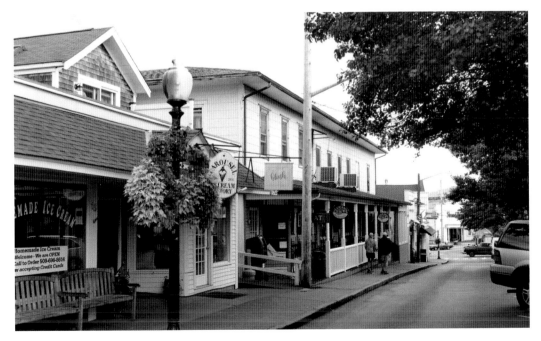

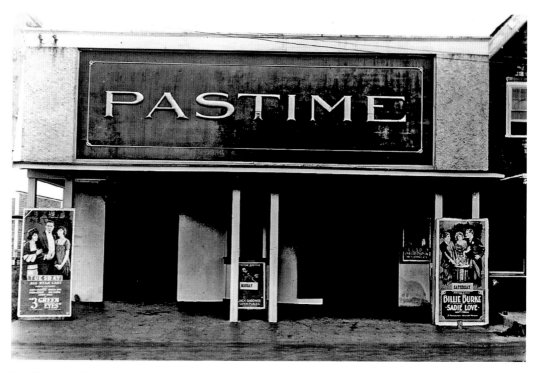

THE PASTIME CINEMA: The poster advertises the silent film *Sadie Love*, a comedy about characters who want to engage in illicit sex but are constantly thwarted before they can follow through. This type of humor created controversy among critics for defying conservative sexual mores. Campground congregants may not have attended, but it does indicate an increase in the social diversity of Oak Bluffs. The film came out in 1919 when the nearby Castle (later Island) and Strand cinemas were also in operation. (*mvm*)

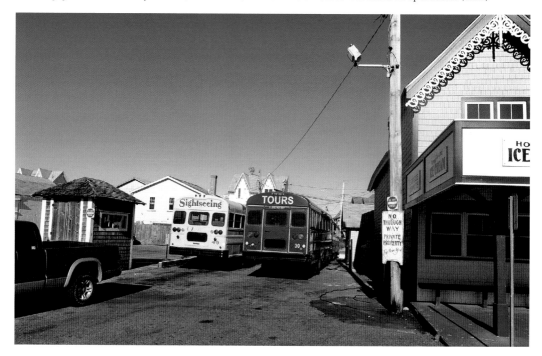

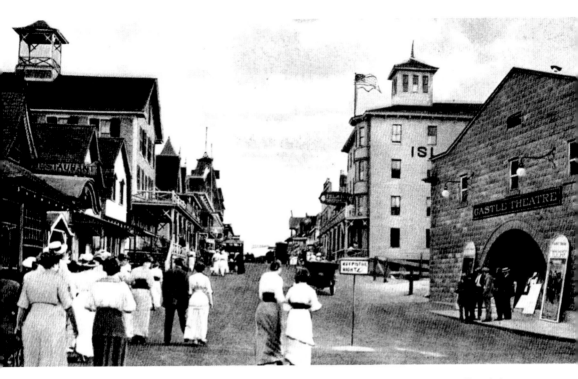

TAKING THE CIRCUIT: At the extreme left is one of the rare buildings that remains on Circuit Avenue from this period and is now a popular restaurant. At right is the Castle Theatre, which opened in 1915 (later renamed the Island). It closed in 2010, and the building unfortunately still languishes. In the distant center the profile of the Arcade building can just be made out. Note the "Keep to the Right" sign, a harbinger of the automobile eventually pushing aside pedestrians who enjoyed "Taking the Circuit." C. 1915. (*act*).

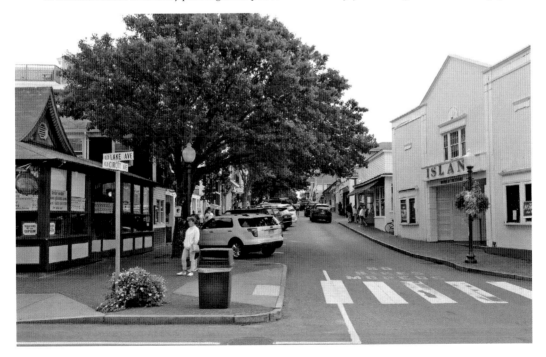

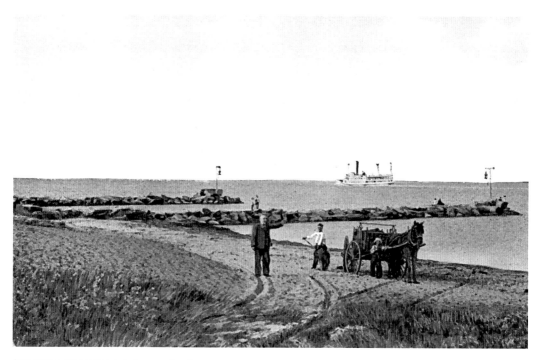

SEAWEED COLLECTING: Seaweed collecting ranged from gathering a single frond to filing a cart. At the more refined end, it was especially popular with woman interested in natural history, a common pastime. At the other end, as shown here near the jetties framing the entrance to Oak Bluffs Harbor, it was harvested in bulk rather than the snipping, drying and mounting of various varieties done by collectors. Matted and decaying seaweed is not the tastiest and here it was likely harvested as fertilizer. C. 1900. (*act, dw*)

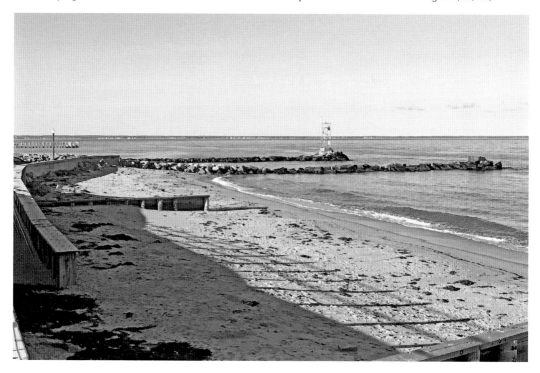

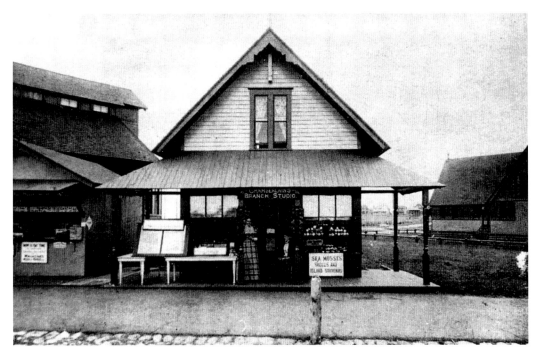

SEA MOSS SHOP: A small shop revealing a popular the interest of early island visitors. Sea moss and seaweed collecting were popular activities for young educated women during this time who sought edifying activities. Many of them came to Martha's Vineyard more for a version of the modern day "field trip" than a day at the beach. Shops elsewhere on Circuit Avenue also sold the paraphernalia needed to clean and display specimens. Ocean Park is seen at right. C. 1905. (*mvm*)

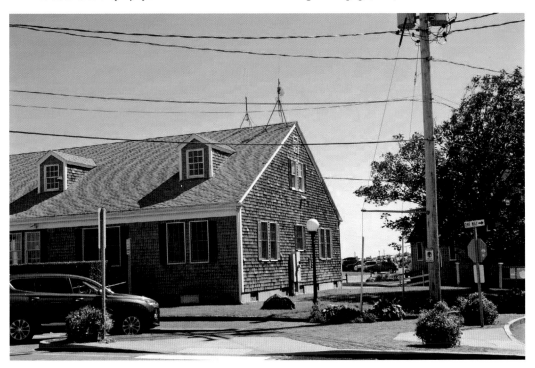

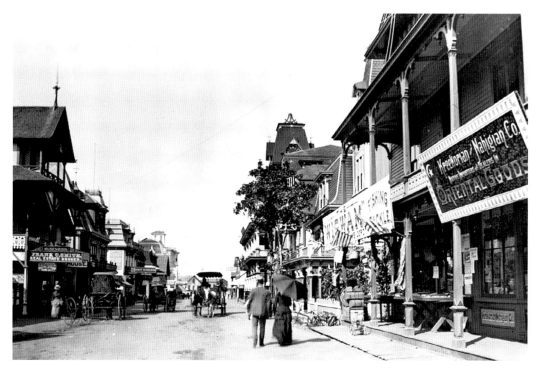

CIRCUIT AVENUE: Circuit Avenue was so named because it made a complete circuit around the entire town of Cottage City (see page 13, top). Shown above is the variety of retail shops and businesses catering to both the visitor and resident. Just visible above center is the clock tower of the Metropolitan Hotel. In the distant left the Island Hotel can just be seen, and the Arcade is the gabled building at the left, the only structure remaining of these three. C. 1880. (*mvm*)

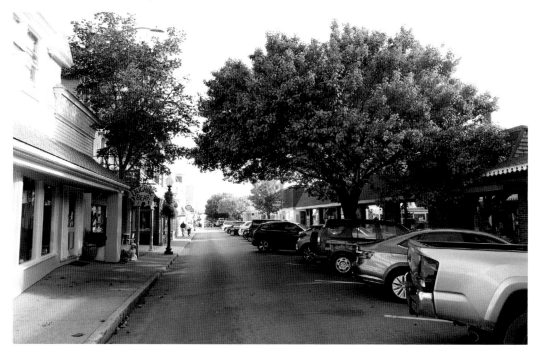

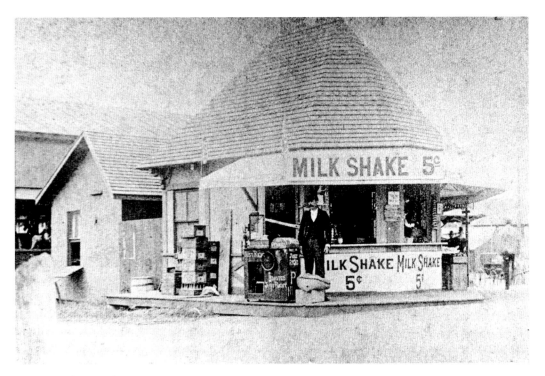

THE SHAKE SHACK: This unusual little structure at the bottom of Kennebec Avenue was where "shakes" were sold for five cents. First available in about 1885, the recipe called for cream, eggs, and whiskey and was often served with other ingredients such as lemonade and soda water. By the turn of the century, this shop had expanded to cater to a wider range of goods targeting tourists. After over 130 years, this little building still remains, albeit abandoned. C. 1890. (*mvm*)

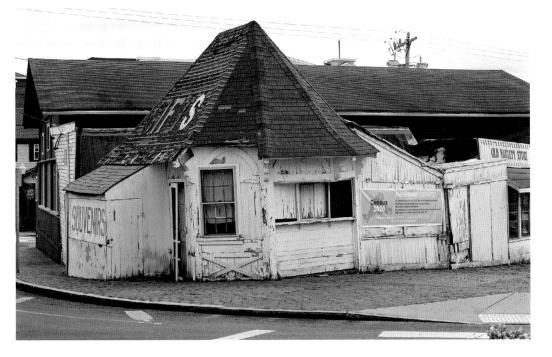

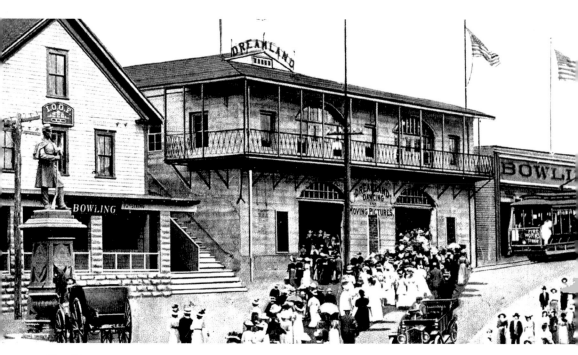

THE DREAMLAND: A building that has cycled through many uses, it was first a destination for the "young set," who came to the island perhaps hoping for a little romance as much as a day at the beach. Dances popular at the time included the foxtrot, turkey trot, and the hesitation waltz. The trolley car indicates this was a stop on the electric trolley line. Neither building on either side of it survives. The style of the automobile sets this at about 1910. (*mvm*)

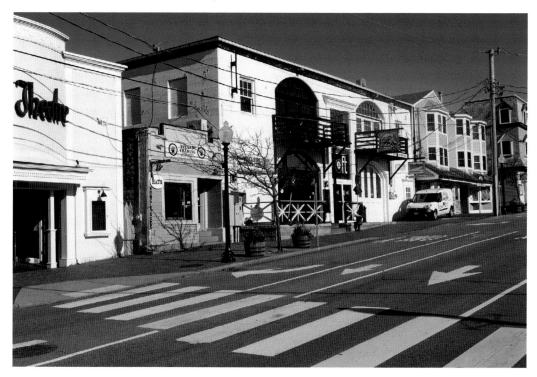

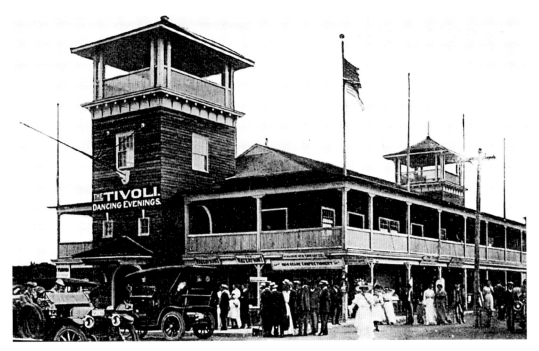

THE TIVOLI: On the back of this postcard "Adelaide" wrote, she was "Having a fine time. In bathing most all the time. Was down street last night." Perhaps she was at the Tivoli, which was built in 1907 with shops on the ground floor and dancing on the second. The largest dancefloor on the Atlantic Coast at the time, it had doors that opened onto a wraparound terrace to let the ocean breeze in and allow the music to be heard on the street below. It was demolished in late 1964. C. 1913. (*act*)

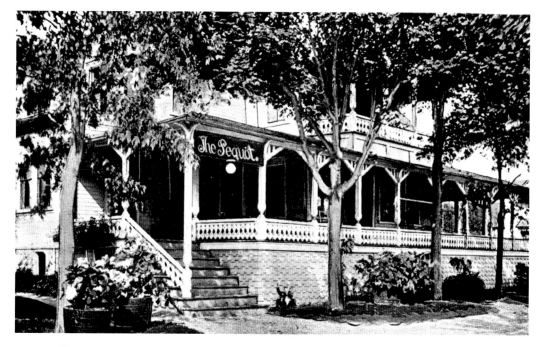

PEQUOT HOUSE: Situated on Pequot Avenue, an early 1887 map lists this as "Pequot Cottage." An early advertisement states it was centrally located on Pequot and Narragansett Avenues near Post Office, parks and electrics. Two minutes' walk from the beach where the facilities for sea-bathing and hot water baths are unsurpassed. This house is widely known for the completeness of its appointments and light airy rooms. Electric lights throughout; delightful environment, cool verandas, perfect sanitary conditions. Is especially noted for the excellence of its table." C. 1890. (*act*)

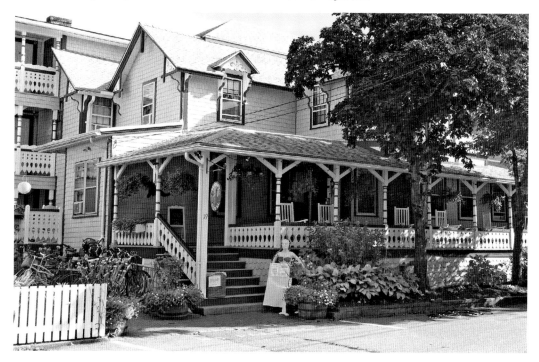

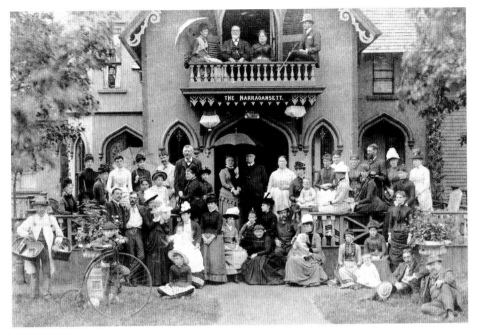

THE NARRAGANSETT: It is still there on Narragansett Avenue. An early advertisement promises that "This elegant and fashionable cottage has recently been put in thorough order and ... Mrs. Hill is confident of being better able to accommodate her patrons than ever before." In the advertisement's accompanying image, a three-story tower is shown that no longer exists. Perhaps it provided the additional space necessary to accommodate all these individuals shown, except for the gentleman at the extreme left. This was "Uncle Nathan," who also appears in the photo on page 59. C. 1890. (*mvm*)

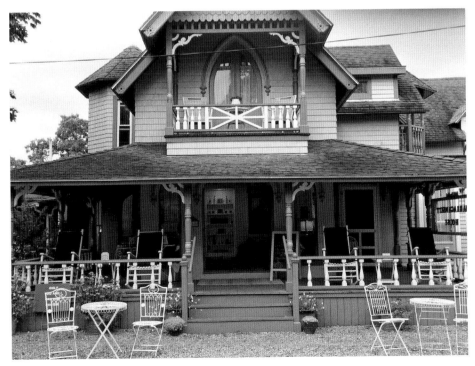

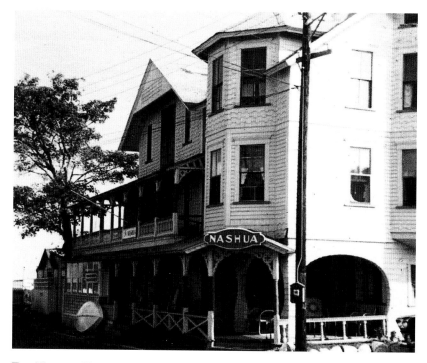

THE NASHUA HOUSE: The Nashua has been at the corner of Park and Kennebec for over 125 years and is shown on an 1892 Sanborn map. Cottage City had major hotels, but also many smaller inns such as this, the Narragansett, and Pequot—typical tourist accommodations of the time. The 1907 Oak Bluffs Directory contains a Nashua House advertisement announcing that "table service can be taken at the Brookline dining rooms." It has recently been renamed the Ginger House. 1968. (*act*)

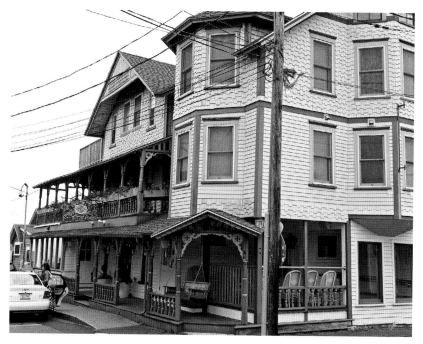

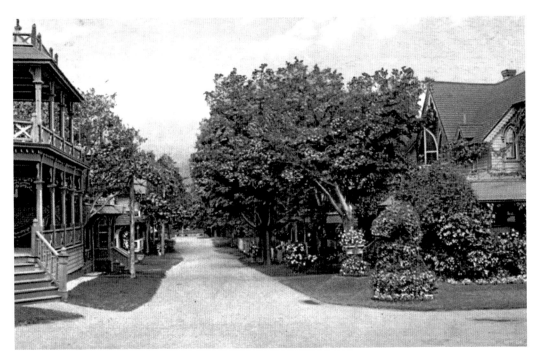

SAMOSET AVENUE: Originally laid out by the architect of Cottage City, Robert Morris Copeland, it is one of the streets that has retained its originally intended name and shows his aversion to straight lines (see page 13, top). In the early planning stages, names such as Suckamuck and Bomozeen were rejected, but we still have Samoset, Kennebec, and Naumkeag. Little has changed since the top image except for the addition of the automobile. C. 1890. (*mvm*)

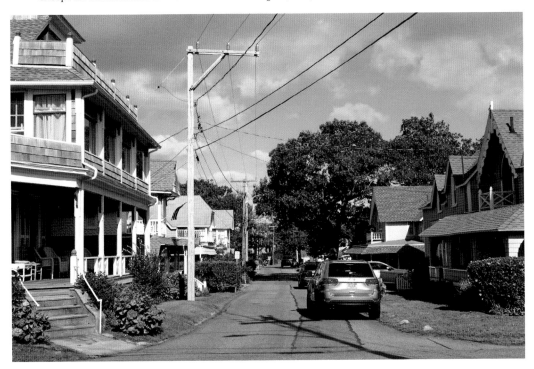

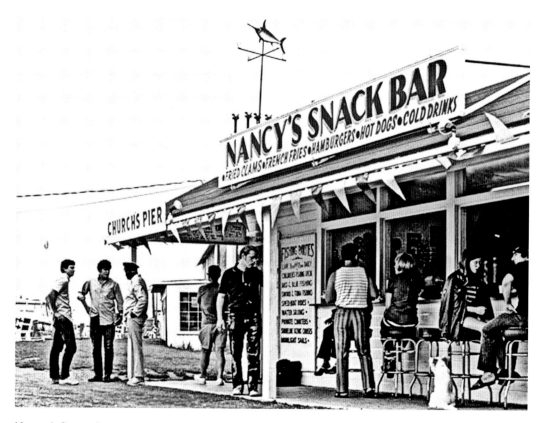

NANCY'S SNACK BAR: The top photo shows a casual eating spot by the dock overlooking Oak Bluffs Harbor. Opened over sixty years ago, its significant expansion, both in size and menu, reflects the island's surge in popularity from the 1960s onward. The menu, at first offering little beyond beer and burgers, now offers lobster rolls, Middle Eastern cuisine, and specialty cocktails. It also has a sushi bar. C. 1970. (*mvm*)

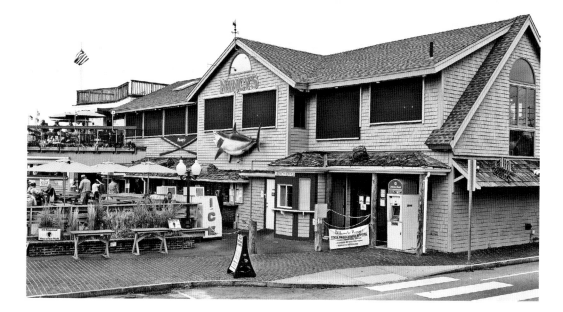

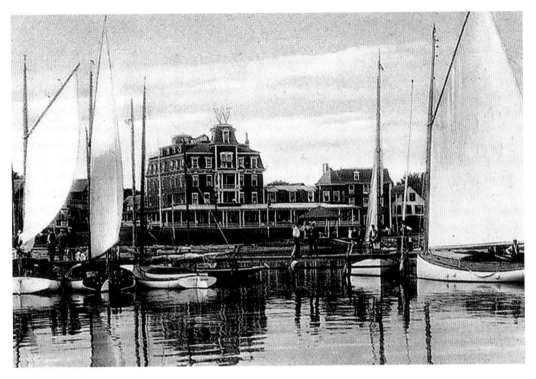

OAK BLUFFS HARBOR: The "W" above the Wesley House places this photograph before 1954, when Hurricane Carol sent it sailing. In the foreground are catboats. These crafts had a single mast with the sail set well forward in the bow. Now mainly chartered by tourists, it was once the primary workboat of the island. The preeminent builder of these boats, Manuel Swartz Roberts, worked out of what is now Edgartown's Old Sculpin Gallery. C. 1920s. (*mvm*)

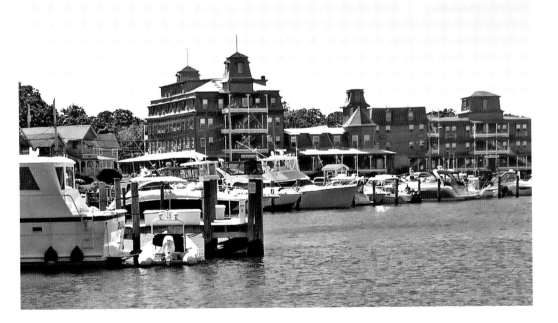

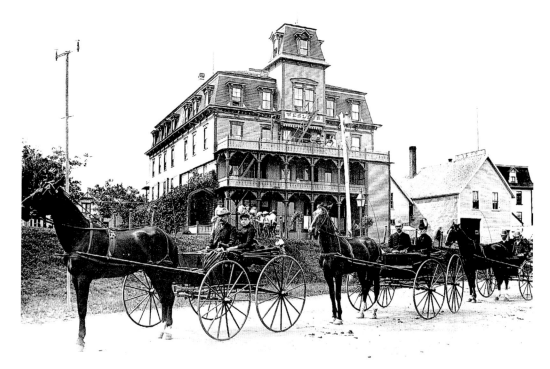

THE WESLEY HOUSE: This is the last one remaining from the era of large hotels. The name has been changed and it is now "Summercamp." Its first advertisement as the "Wesley House" was in 1875 with the original front located at what is now the rear of the building where several retail businesses operated. This area, known as Commonwealth Square, was a Campgrounds "business district." The shops, including the magnificently articulated "Japanese Shop," closed as the hotel expanded, eventually moving the main entrance to face the harbor. C. 1890. (*mvm*)

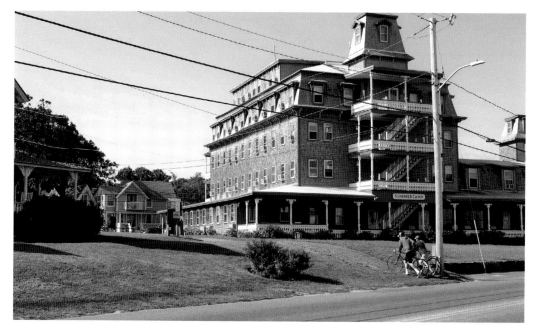

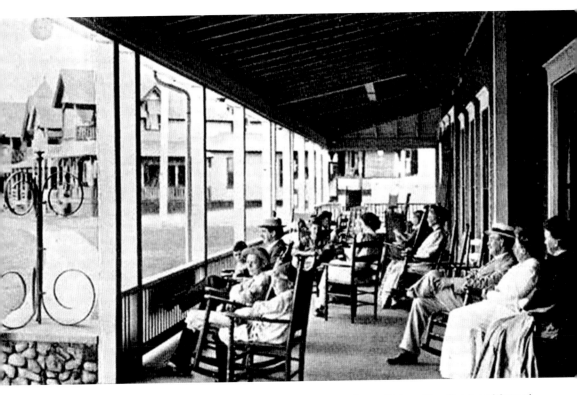

THE HOTEL PORCH: The Sea View House, Island House, Pawnee House, Metropolitan Hotel, and Central House along with the Wesley all had porches or verandas. Every cottage, inn, or hotel built during this period had one. The planning of early Oak Bluffs was not imagined without them. The Wesley's shared common space still enables visitors to socialize and swap stories about their stay. C. 1900. (*mvm*)

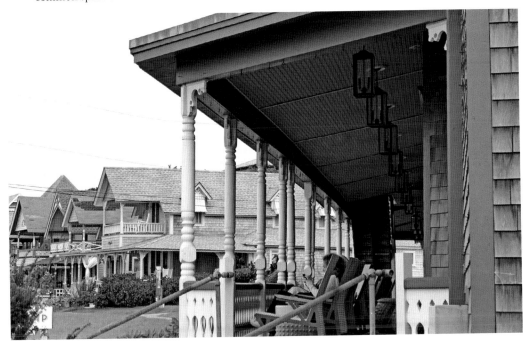

LAKE ANTHONY: Oak Bluffs Harbor was at first a landlocked body of water. Early colonists knew it as Squash Meadow Pond. Later, it became Lake Anthony and is now Oak Bluffs Harbor. At the time of this photo, the sand bar had already been dredged out creating direct access to the sea. Longstanding legal conflicts, however, prolonged the development of the waterfront. This view looks towards New York Avenue and the road to Vineyard Haven. C. 1930. (*mvm*)

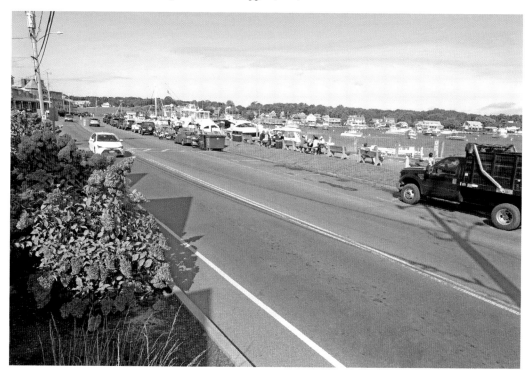

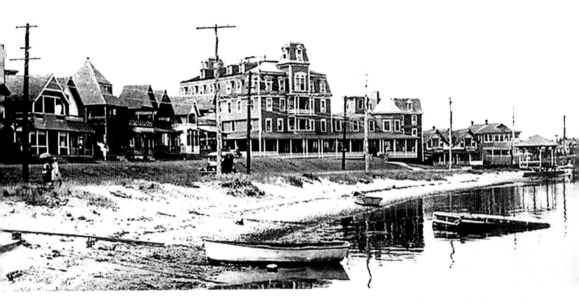

HARBOR DOCK, THEN AND NOW: In 1900, Lake Anthony was permanently opened to the sea by dredging a 100-foot-wide channel through the barrier beach that had separated them to create Oak Bluffs Harbor. The top photo shows a "natural" waterfront and the small beach shown was created using sand dredged from the channel. Eventually, the southern and western sides of the harbor were developed to accommodate small pleasure craft and the summer sailor. C. 1930. (*mvm*)

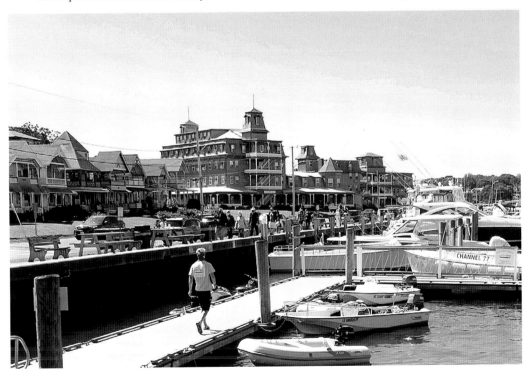

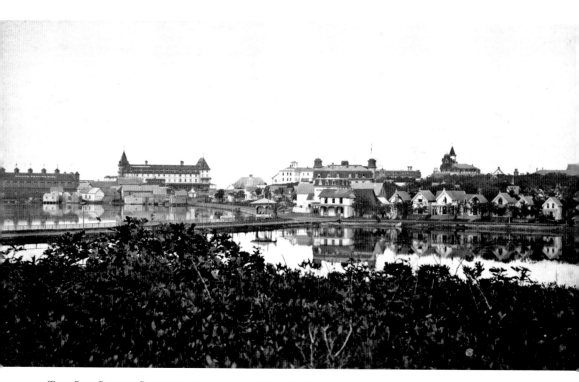

THE OAK BLUFFS SKYLINE: The road out of Oak Bluffs leading to Vineyard Haven can be seen at left in the top photo. This view across Sunset Lake shows early Oak Bluffs looking eastward. From the left is the skating rink (note roof signage), Sea View House, Island House, Wesley House, Pawnee Hotel, and the Metropolitan. All that remains is Wesley House (now Summercamp), identifiable by the two small towers in the bottom photo. C. 1890. (*mvm*)

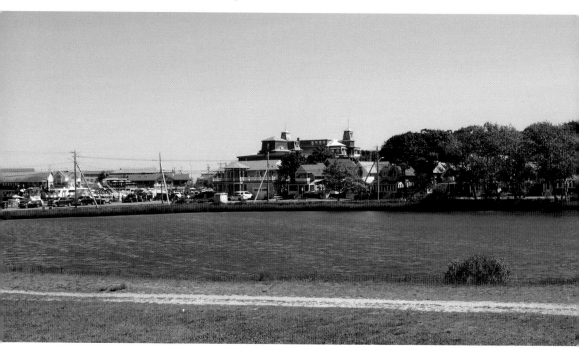

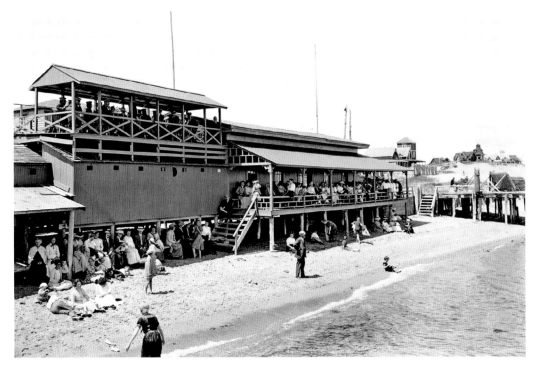

EAST CHOP ENTERTAINMENT: Now private, this section of beach at the location of the former Highland Hotel and Highland Wharf was the northernmost extent of the Oak Bluffs public beach. Despite the bathhouses, many are fully dressed and clustered in the shade. Above at left is a band that provided entertainment for those wading or watching. Bands were not only heard from here, but from the Tivoli, Dreamland, from the veranda of the Pawnee House and Ocean Park's bandstand, all providing a holiday soundtrack. C. 1890. (*hne*)

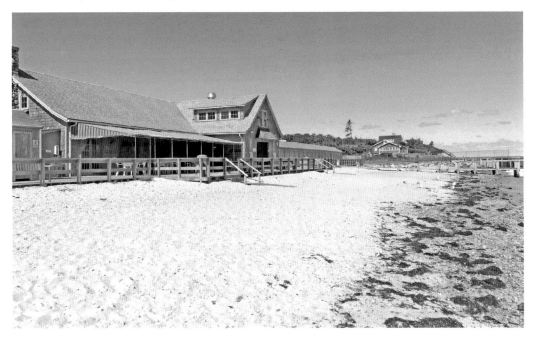

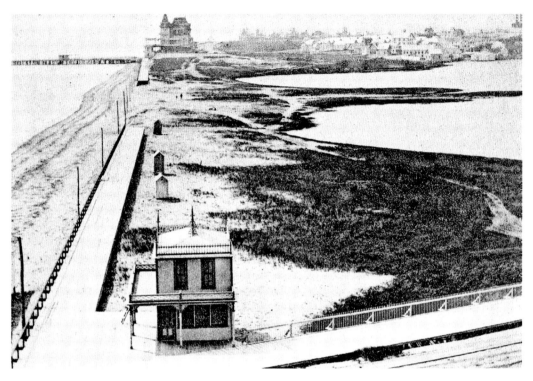

THE BARRIER BEACH: This southerly perspective was taken from the Highland House that can be seen in the distance looking beneath the toboggan structure on page 57. A barrier beach once separated the sea and Lake Anthony as shown above. The break in the boardwalk is at the location where later dredging took place to make the opening that created Oak Bluffs harbor. The Sea View House can be seen near the top of the frame while trolley tracks to the Campgrounds can just be made out in the lower right. C. 1890. (*mvm, dw*)

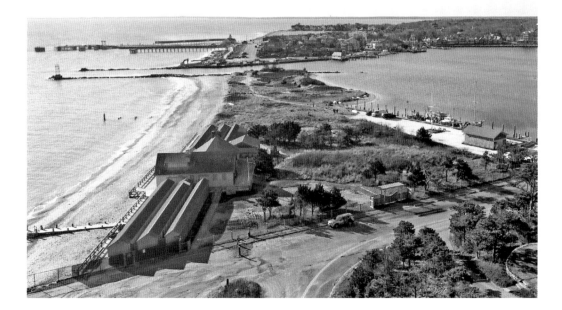

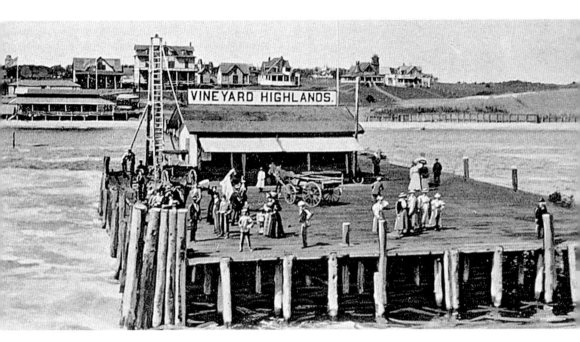

HIGHLAND WHARF: Built in 1871, it served customers of the Highland House Hotel built to compete with the Sea View House and was also the preferred arrival point for those coming for Campground services. Disembarking at the Cottage City wharf, 1,000 yards away, meant running a gauntlet of distractions before entering the Campgrounds. Arriving at Highland Wharf, one could avoid all temptation and "cross over Jordan" along what is now East Chop Drive. A trolley can be seen just to the left of the ladder. C. 1880. (*mvm*)

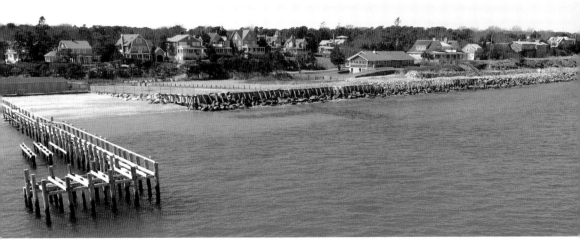

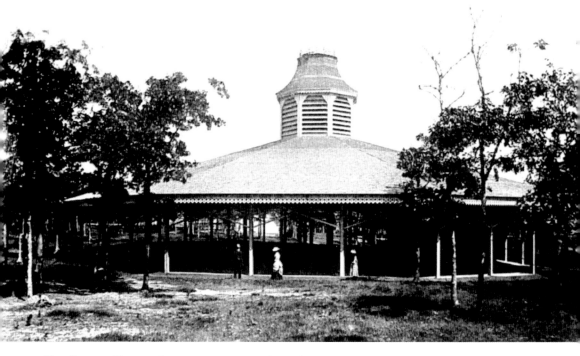

THE BAPTIST TEMPLE: Beginning services in 1871 in the Highlands section, it was the first permanent structure erected for summer meetings here. The Methodist association had reserved the site in anticipation of the encroaching worldliness of Oak Bluffs. In the end, they remained where they were, and the site was transferred to the Baptists. The temple rose in angular roof planes that met at an ornamental peak. High ceilinged with spacious entrances, it adapted well to its purpose. The structure lasted until the 1960s, with services ending thirty years before. The site is now Baptist Temple Park. C. 1880. (*loc*)

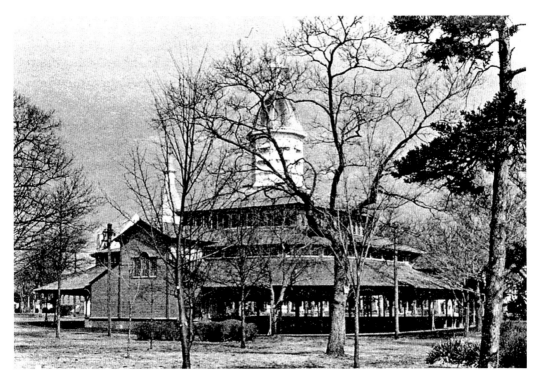

THE TABERNACLE: Opening in 1879, it is an important American building built by Dwight and Hoyt of Springfield at a cost of just over $7,000. This psychic center of the Campground was silent until that moment when an aggregate of voices soared into the summer night, producing a rapturous hymnal heard as far away as Ocean Park. The celebratory and egalitarian clamor of these early meetings still echoes across the Campgrounds today in concerts, community meetings, and graduations, providing a cultural touchstone at the core of the island experience. C. 1885. (*mvm*)

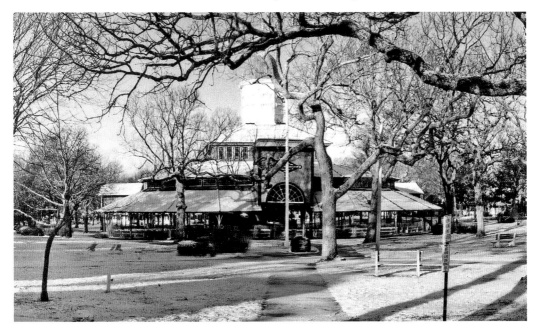

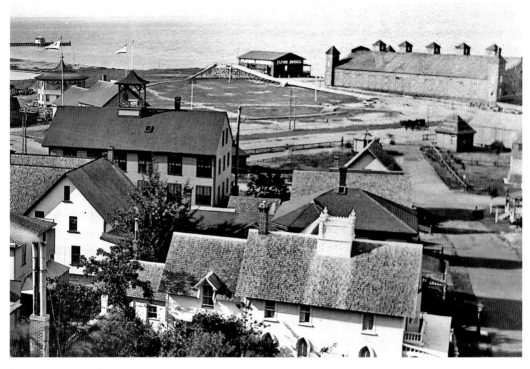

FILLING IN THE SPACE: A view from atop the old Pawnee House. The Flying Horses carousel is just behind the roller-skating rink and, next to it, the toboggan ride (page 57). Cottage City's investors hoped to copy the mainland mania for amusement parks here, an attempt that failed. Note the octagonal structure behind the leftmost flagpole. This was Pratt's pavilion moved from Ocean Park (page 72). An 1898 Sanborn map labeled it as "old and vacant." The large building left of center with the cupola is Searell's House, once a Circuit Avenue landmark hotel. C. 1887. (*mvm, dw*)

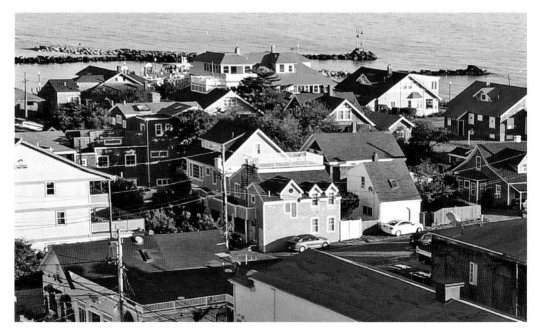

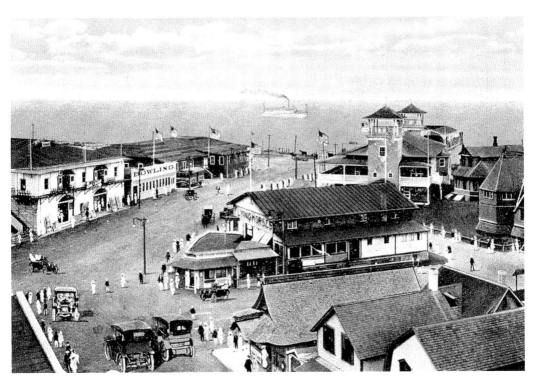

A WHOLESOME OAK BLUFFS: Likely taken from the roof of the Island House hotel. In this view there are two dance halls, the Dreamland at left and the two towered Tivoli at right. There was also a cinema on the ground floor of the Dreamland building. To the right of "Bowling" was the new skating rink (from a 1915 Sanborn map). In the center is the relocated Flying Horses carousel—all wholesome activities. The automobiles date this at about 1915. (*mvm, dw*)

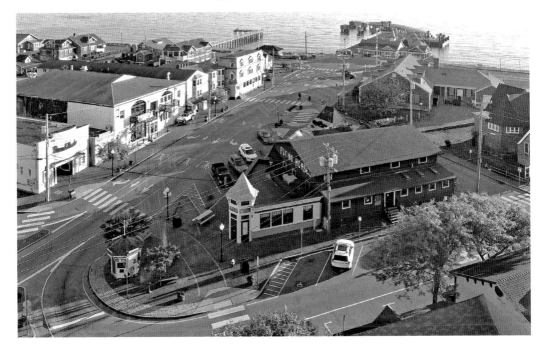

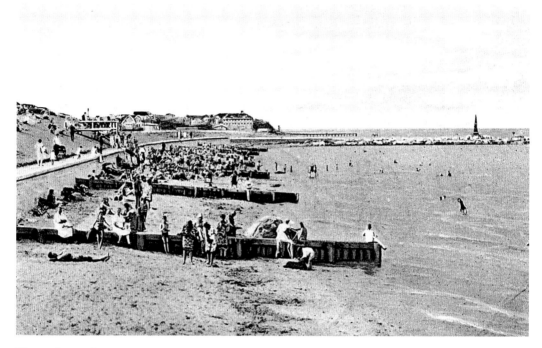

NORTH BLUFF BEACH: Also known as West Chop Beach, this small stretch is located just north of the wharf in Oak Bluffs. This area is just to the right of the original location of the Flying Horses that can be seen in both images on page 13. Over the years, the concrete wall weakened and was replaced in 2016 with a higher steel piling wall, corrugated to break the impact of the waves and slow, if not prevent, continued erosion. C. 1920. (*mvm*)

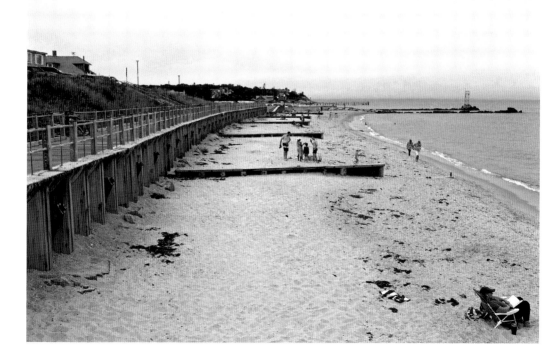

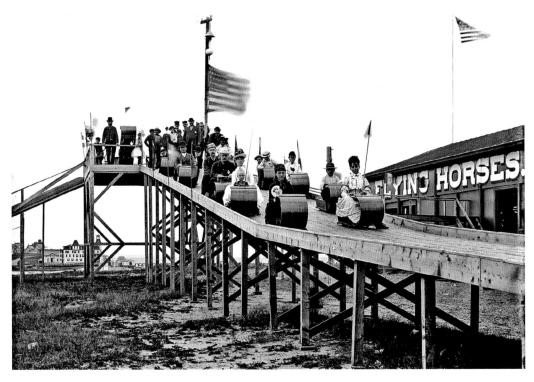

SUMMER TOBOGGANS: Constructed in 1887 next to the Flying Horses the "toboggan" ride brought an initial descent to a tame 800-foot elliptical course. The lack of any real speed or thrills may account for its lasting only one season. The Flying Horses was initially located behind the Skating Rink (page 54), about 350 feet from Oak Bluffs Avenue, according to its position on an early Sanborn map. The site of this nascent amusement park now consists of homes in the North Bluffs area. The back garden shown below is the approximate location of the above photo. C. 1888. (*mvm and owner's permission*)

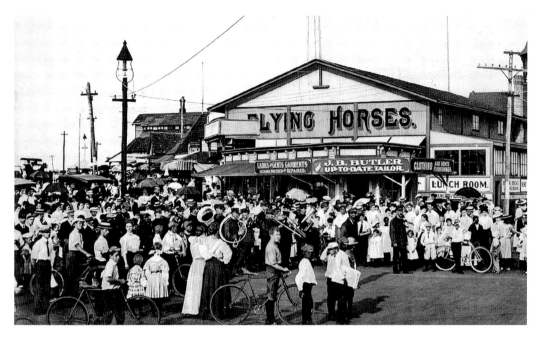

FLYING HORSES: The oldest continuously operated carousel in the country, its horses were hand carved in New York City in 1876. In 1884, it was installed behind the Skating Rink (later the Casino) out on the north bluffs (previous page). In 1889, it was moved to its present location. It still has the original horses and brass ring dispenser. Because most riders are right-handed the carousel moves counterclockwise to make it easier to "grab the brass ring" from the original dispenser. The top photo shows an early Fourth of July celebration. C. 1910. (*mvm*)

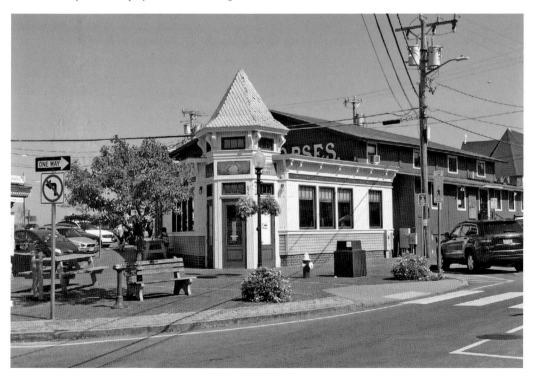

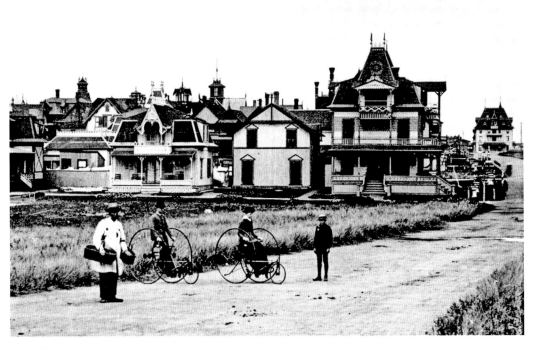

EARLY MOPEDS: Cottage City was popular with cyclists because of the extent of paved roads. The tricycle, as shown here, was the moped of its time, a source of casual recreation and an annoying presence as it could reach, for those times, "reckless speeds." It was banned from Circuit Avenue in 1884 and one contemporary newspaper account worried that children might be run over by one of these "modern chariots." On the left is Uncle Nathan, a blind seller of sweets and popcorn from his baskets, and a well-known figure around Cottage City for decades. C. 1885. (*mvm*)

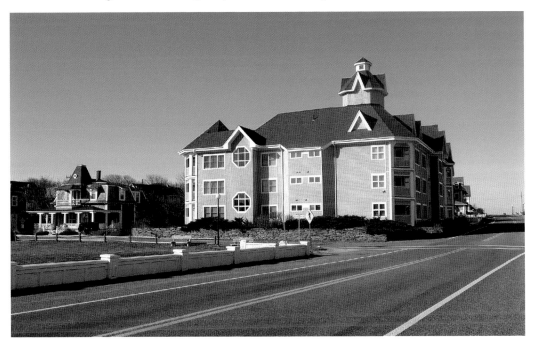

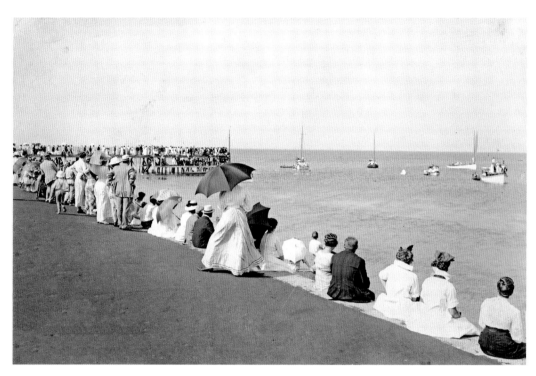

LADY WITH UMBRELLA: A common site in early Oak Bluffs when women often carried a parasol or umbrella. Suntans were not fashionable (only outdoor laborers were tanned), and suntan lotion would not be available for another forty years. The above image was taken C. 1909 with Waban Park behind the photographer. Crowds such as this, in attendance here of what looks to be catboat races, no longer appear along the seafront except perhaps for fireworks on the Fourth. Note how near the water is to the seawall, indicating a small usable beach area. (*hne, dw*)

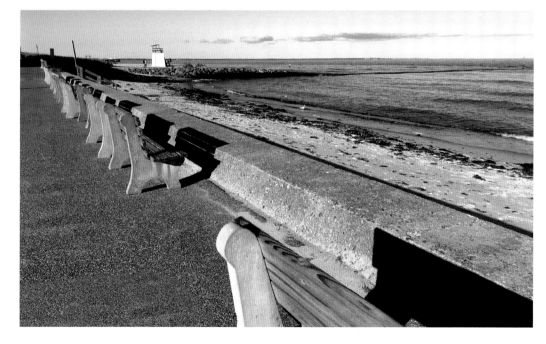

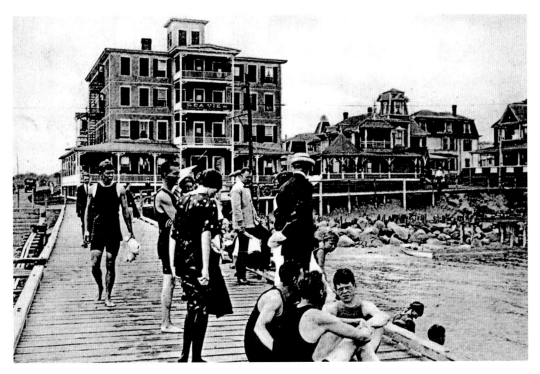

THE SECOND SEA VIEW: Opened in 1907, it was advertised as the "finest located hotel on the Island." It had a chandeliered ballroom where guests wore formal attire. Much later, a more down-market crowd boogied to the beat of popular local bands on that same ballroom floor. The bathers on the pier wear swimming costumes indicating continuing changes in style. On the beach just below the house at right, a portion of the old railroad trestle can just be seen. This Sea View was replaced by a condominium complex in the 1980s. C. 1920. (*mvm, dw*)

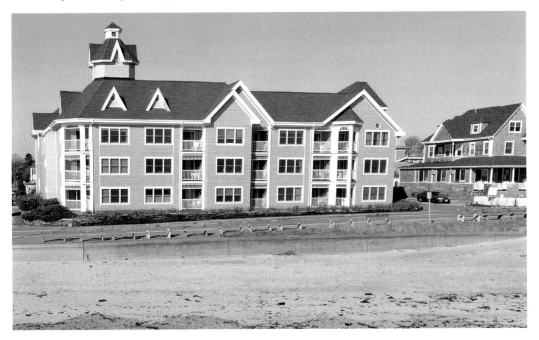

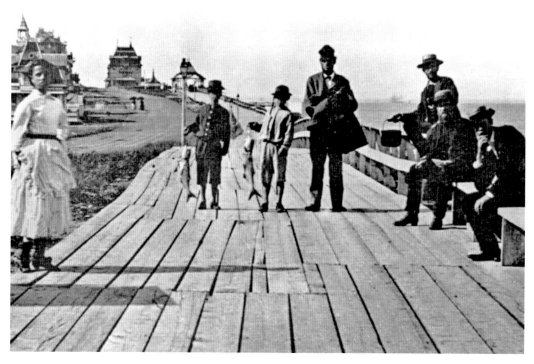

THE BOARDWALK: The boardwalk or "plank walk" was built along the bluffs in the summer of 1871. Extending about half a mile south from the ferry wharf, it replaced a somewhat tawdry grassy and muddy path. It made for better strolling conditions when you were "dressed for dinner." When first built, it was a continuous, unbroken pathway. Later, a "pagoda" was added (see page following), presumably to offer relief from a sultry summer sun while wearing a bustle dress. C. 1875. (*mvm*)

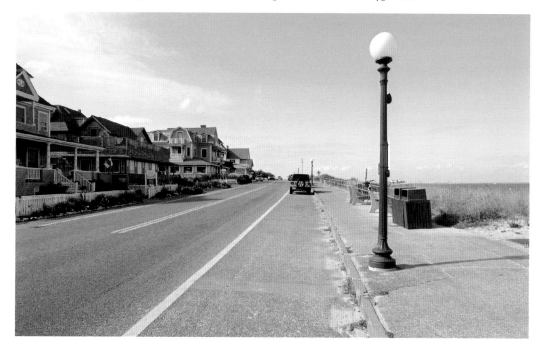

A PRATT PAGODA:
Samuel Pratt's first boardwalk pagoda, showing his signature cresting and flaring of the roof line. The reason for its location, where Samoset Avenue runs into Sea View Avenue, is likely because it was a point of beach access. It also broke up the long boardwalk, created a meeting point, and shade. Here, fully dressed visitors cluster in its shade. It was absorbed into the construction of a viewing tower, bathhouses and a small dance hall constructed out over the water. These changes can be seen on pages 66 and 67. C. 1880. (*mvm*)

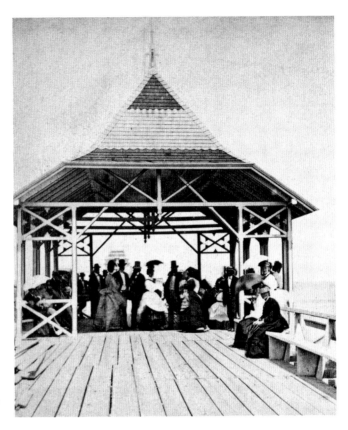

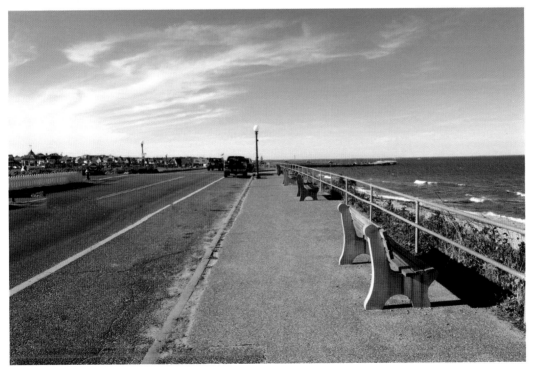

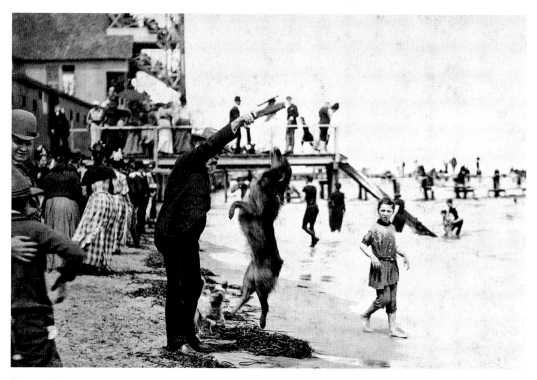

BEACH DOGS: The top image is a rare candid photo for a time when slow shutter speeds made for stiff subjects. It also another example of fully dressed beachgoers, typical and acceptable for the time. For those wishing to "sea bathe," bathhouses shown at left provided shelter for changing. The seaweed showing the high-water mark indicates the narrowness of the beach when the tide was in. Above left, the stairs on the "bathing tower" can just be seen. C. 1880. (*mvm*)

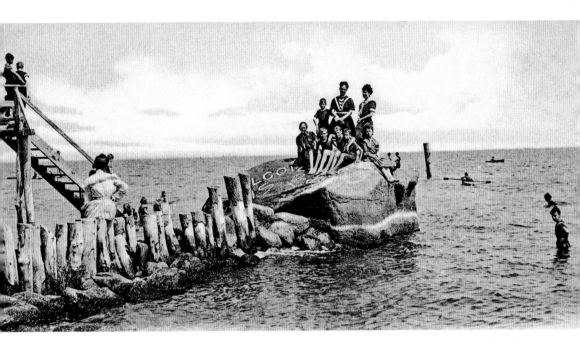

LOVER'S ROCK: Once the island's most popular place for group photos, Lover's Rock was an "erratic," deposited as the massive glacier once covering the entire island receded. Unlike another well-known deposit, Plymouth Rock, it was not protected. It was still visible until 1973, when the beach was raised and extended by dumping tens of thousands of cubic yards of sand, burying it in the process. In the bottom photo, the large granite boulder, appropriated for beach paraphernalia, marks the spot. C. 1885. (*mvm*)

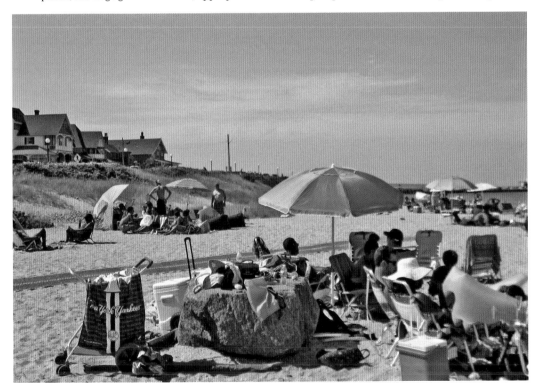

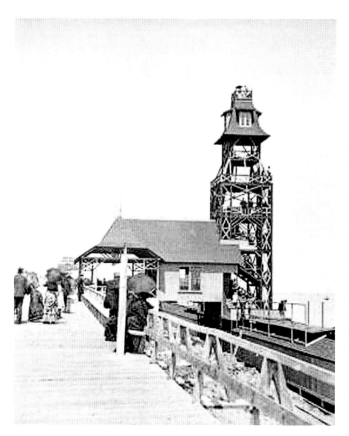

THE OBSERVATION TOWER:
The 75-foot observation or
"bathing tower" provided
panoramic views in all
directions of the beach below,
Vineyard Sound, and the
island itself. For many, it
provided a first aerial view
and was a novel experience.
It stood on the section of
beach where Samoset Avenue
runs into Sea View Avenue
and became architecturally
merged with the nearby
pagoda. The skeletal
framework was a landmark
and reference point until
it was taken down in 1895.
C. 1890. (mvm)

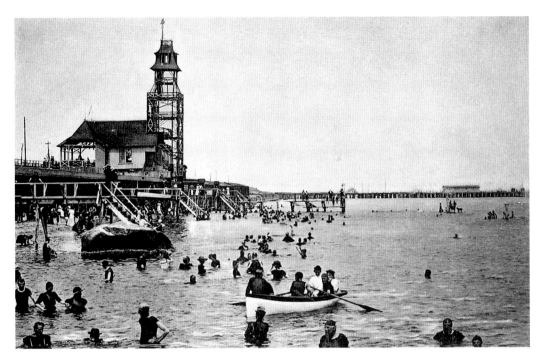

A DAY AT THE BEACH: A view looking north with the Cottage City ferry wharf in the distance at right. Lover's Rock is prominent at left of center, while The Sea View House hotel, destroyed in 1892, no longer captivates the view. The Observation Tower came down in 1895 and dates the photo before that. Note the almost complete lack of a sandy beach. What little there was, was appropriated by the bathhouses and railroad trestle. C. 1893. (*loc*)

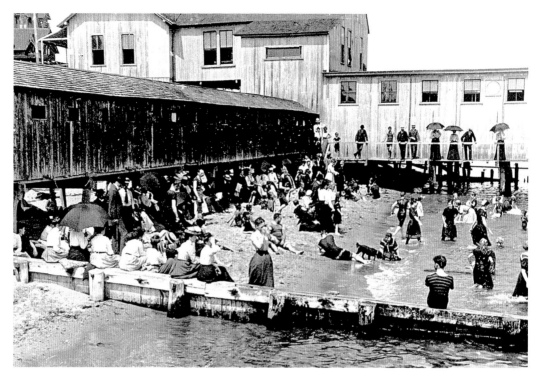

EARLY KODAK MOMENT: A cramped strip of beach before blankets or beach umbrellas were commonplace. In the upper left corner, a bit of the pagoda (page 63) can be seen to help situate this photo. Note the small rectangular openings in the line of bathhouses at the left. These were "windows" and the only source of light or ventilation once inside. In the lower center, a young lady is taking a photo of the fellow at right. C. 1890. (*mvm*)

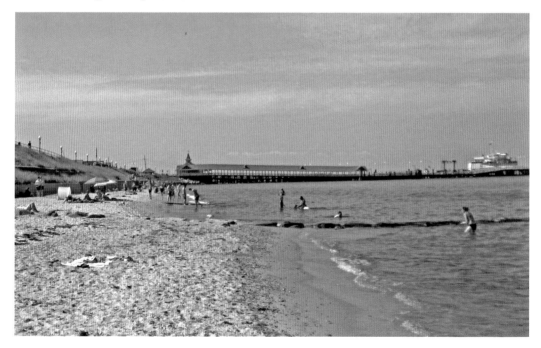

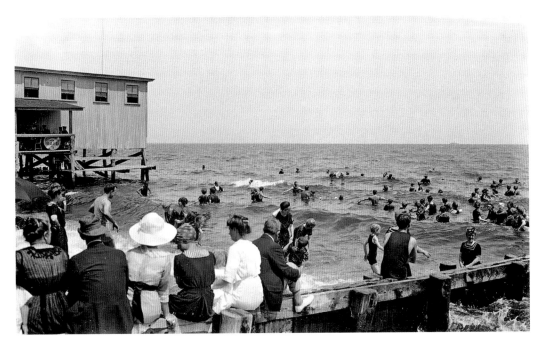

WAVE WATCHERS: In this beginning era of "sea bathing," it was common to see people fully dressed who were there to simply watch those in bathing costumes wading in the waves, still something of a novelty. A band in the balcony above left appears to have been playing when the photo was taken. Live music was very common in Cottage City in the summer season. You could walk anywhere and remain within earshot of popular tunes of the day such as "Plum Pudding" or "Five Cent Shave." C. 1885. (mvm)

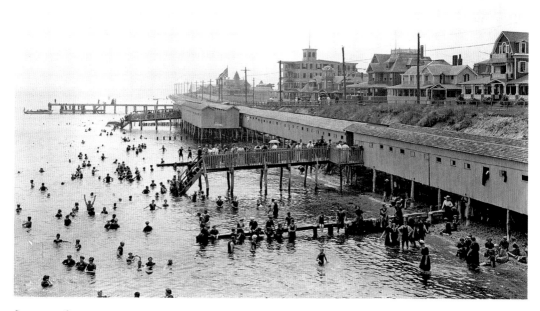

SUMMER CROWDS: A view to the south along the beach at Cottage City. The "new" Sea View is hotel at right of center, dating this photo after the fire that destroyed the first Sea View Hotel in 1892. The bathhouses remained until 1944 when they were storm damaged. Note the bathing costumes hanging to dry from the bathhouse openings. The wider beach in the bottom photo is due to its expansion in the 1970s. The dark stumps in the right foreground are remains of the trestle that once supported rail tracks over the beach. C. 1895. (*hne*)

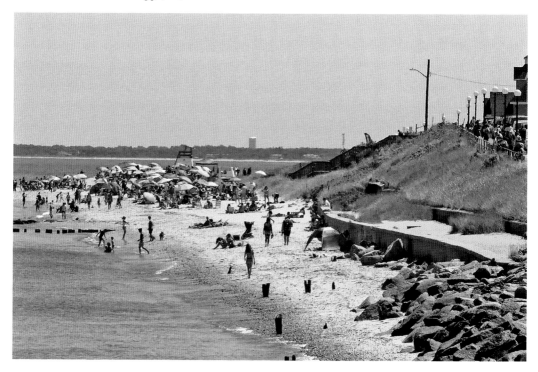

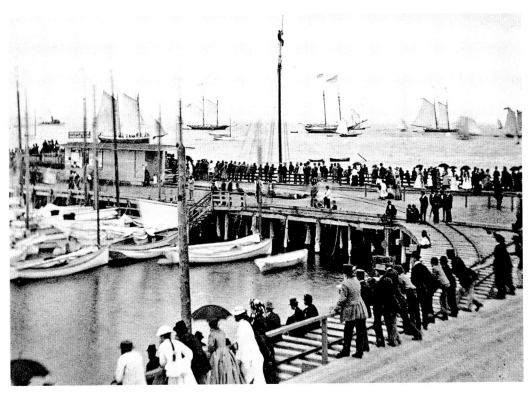

REGATTA DAY: This is a view of the Oak Bluffs ferry wharf looking south. Onlookers crowd the wharf with catboats moored below left. In the distance the reason for the onlookers can be seen, yachts in for a regatta, possibly sponsored by the Edgartown Yacht Club that began in 1905. The yacht club sponsored four regattas in 1905 (when the top image was taken), one of which was a "Ladies Race," in which "boats must be steered by ladies only and any boat whose tiller or wheel is touched by a man, excepting to prevent an accident, shall be disqualified." (*mvm*)

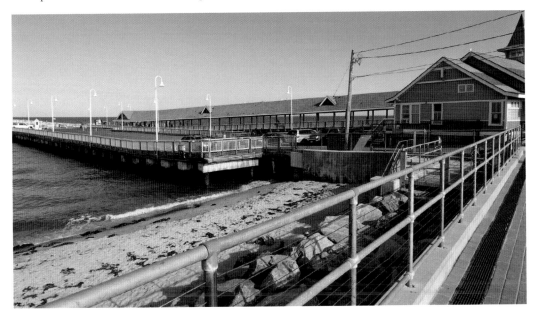

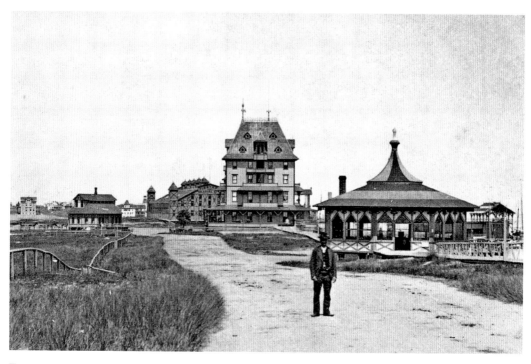

THE NEW PAGODA: Another of Pratt's designs, this eye-catching structure once sat at the top of the bluff across from the approximate midpoint of Ocean Park. It was a meeting place and refreshment stand, which provided access to the beach below via a stairway from the inside and just visible in the photo following. Built in 1872, it is not shown in the panoramic drawing on page 13 published in 1890. By then, it had been moved next to the toboggan track and can be seen on page 54 at left. C. 1875. (mvm)

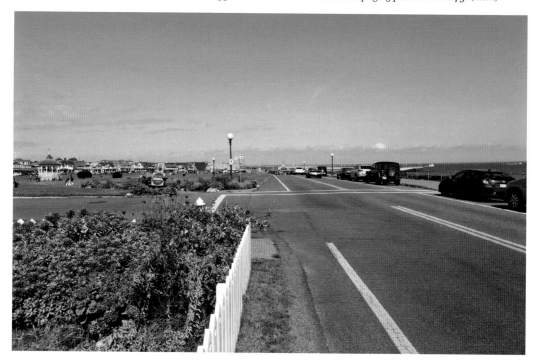

BOARDWALK AERIAL: Many early Cottage City photos show visitors gathered either to celebrate the Fourth or perhaps as spectators to a boat race. The beach is empty of bathers, perhaps in part to the fact that bathhouses had not yet been added and there was nowhere to change into a bathing costume. Pratt's smaller, earlier pagoda can be seen in the distance as well as the tracks for the train to Katama below left. The photo would have been taken from atop the Sea View House, shown on the previous page. C. 1875. (*bpl, dw*)

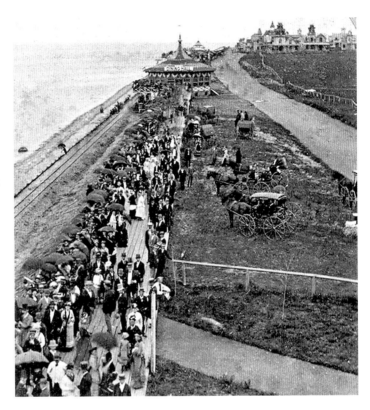

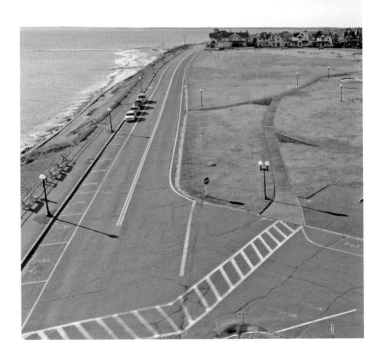

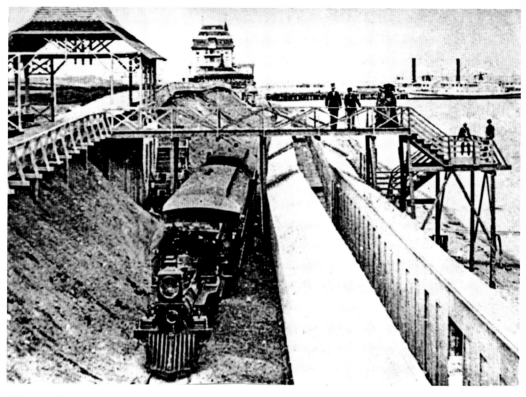

A LOCAL STOP: From the left are Pratt's early pagoda, the "Active" locomotive to Katama, and the bathhouses. Typical exposure times and the fact that the engine is not blurred suggest the train was stopped. This was in fact a "commuter stop" for those working in Edgartown. It is easy to see how winter storms would frequently wash away the sand on which the track was laid. When it first opened in 1874, the fare was 75 cents for a round trip journey to Katama. C. 1880. (*mvm*)

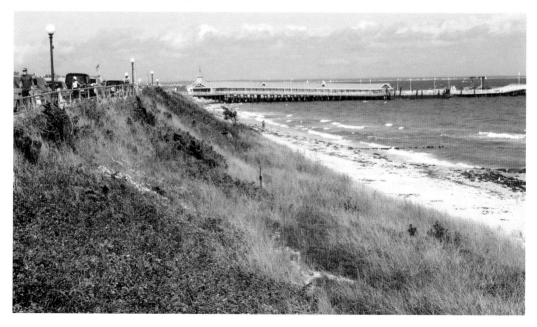

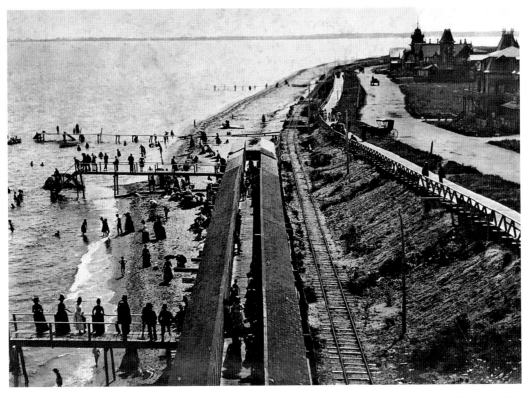

THE BATHHOUSES AND RAIL LINE: The view looking south with Sea View Avenue on the right. The bathhouses in the center of the photograph appear busy, yet many beachgoers remain in their normal street attire. It must have been somewhat arduous for ladies to change into their swimming costumes in a cramped cubicle, wade for a bit, and then stand about in a damp costume slow to dry. Lover's Rock can be seen left of center, with purpose-built access. C. 1880. (*mvm*)

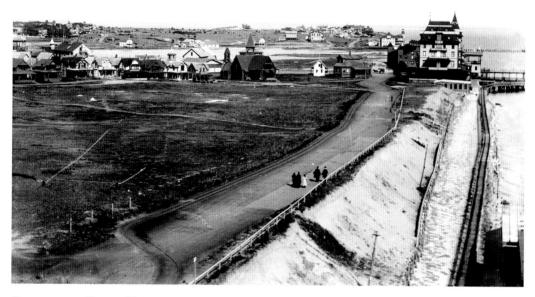

OBSERVATION TOWER NORTH: The view looking north form the Observation Tower. The viewing platform was 75 feet above Sea View Avenue or about the height of a seven-story building. The darker structure just above the center is Trinity Episcopal church with the roof of Pratt's relocated pagoda just visible behind it. Behind the Sea View House is the Vineyard Skating Rink. A noteworthy aspect of this view is how treeless the Highlands section was at that time. C. 1880. (mvm, dw)

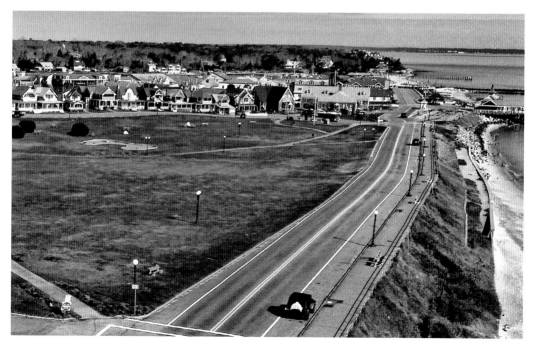

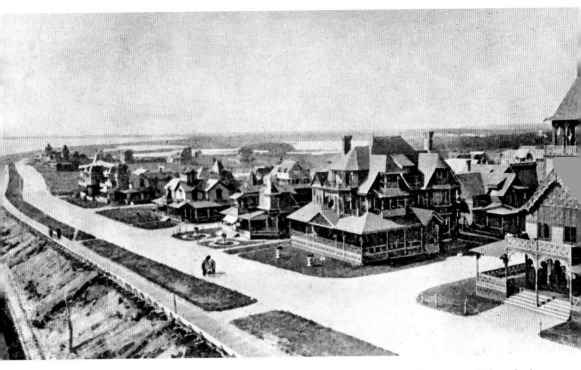

OBSERVATION TOWER SOUTH: The image on the previous page shows the view you would have had from atop the Observation Tower looking north. Doing an about face gave you the view looking south along Sea View Avenue. The bathhouses, barely visible in the lower left, along with the railroad track are absent from the contemporary view showing how remarkably little has changed except for a larger beach area. C. 1880. (*mvm, dw*)

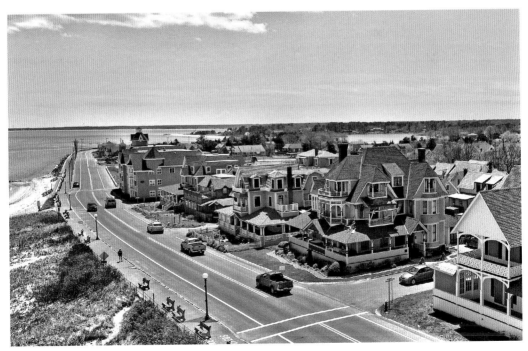

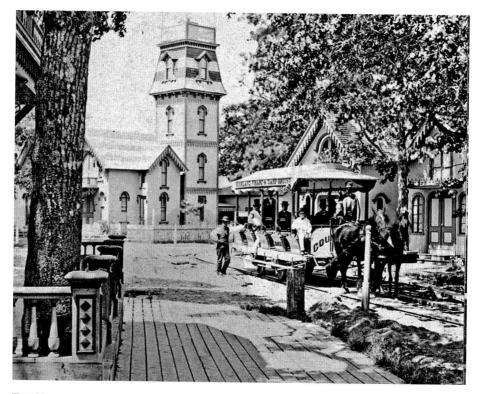

THE HORSECAR: Horse-drawn trolleys, also known as horsecars, were a part of the Oak Bluffs Street Railway, completed in 1873. Shown here is a horsecar in the Campgrounds approaching the loop around the Tabernacle before heading back to Highlands Wharf. Campground congregants could arrive at Highlands Wharf, board a trolley, and head directly into the Campgrounds, avoiding Cottage City's temptations altogether. The building just behind the trolley is today's Cottage Museum. C. 1875. (*mvm*)

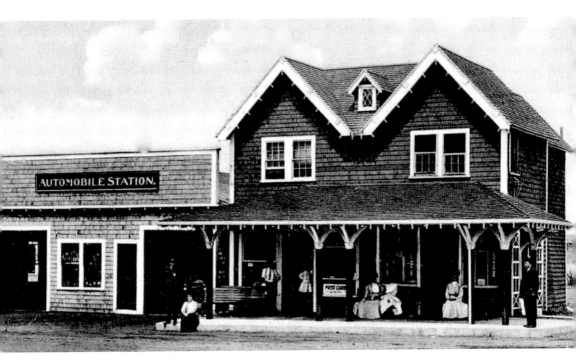

TROLLEY STOP: Horse-drawn trolleys were soon followed by electrified cars. The line once ran from out beyond Barnes Road, Wing Road, Nashawena Avenue, along Sea View Avenue, past the Dreamland, onto New York Avenue, Temahigan Avenue, and along Beach Road into Vineyard Haven. The former trolley stop shown here is the only remaining structure of either the trolley or the Martha's Vineyard Railroad that reached Katama. The automobile station shown was the former site of the Pastime Cinema on page 30. C. 1915. (*mvap*)

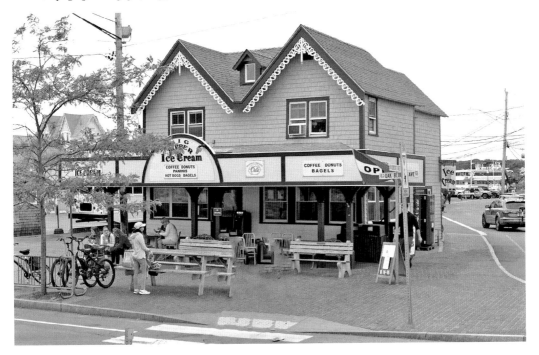

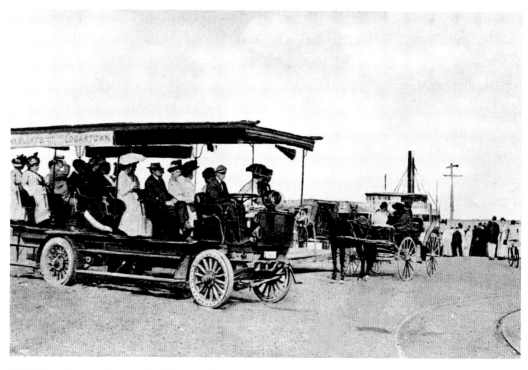

NEW TRANSPORT: Above is the "Twentieth Century Limited," a jitney that carried passengers for five cents, "jitney" being a slang term for a five-cent nickel coin. The sign along this one reads "Oak Bluffs to Edgartown." By 1918, they put the island's trolleys out of business by running along the same routes and more (note the tracks, lower right). Improved road conditions meant an increase in the number of motor cars, leading to the end of horse-drawn carriages on Martha's Vineyard altogether. C. 1910. (*mvm*)

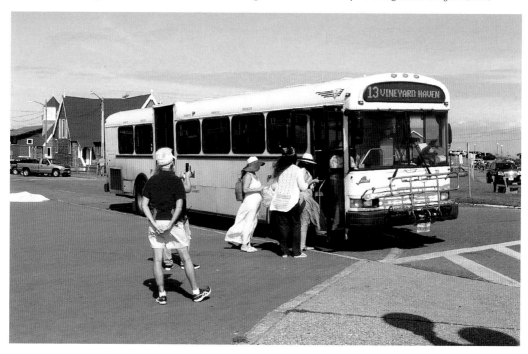

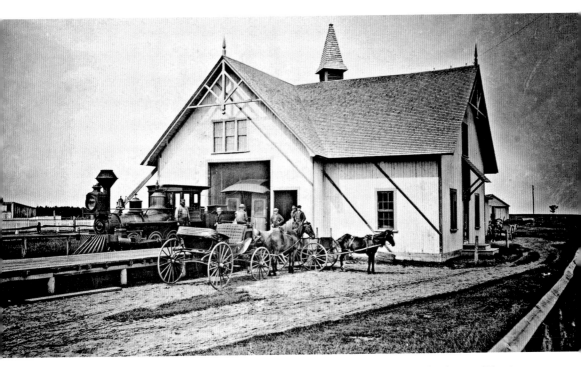

EDGARTOWN DEPOT: The Martha's Vineyard Railroad's primary building was the depot at Edgartown. Its location was near to that of the current Depot Service Station. Note the smaller-sized engine to accommodate the track's 3-foot gauge. This was a rare "run-through" building or a depot that the train passed through on its journey to or from Katama. This narrow-gauge railroad was not setting "island precedent." A similar railroad on Nantucket preceded it by three years. C. 1885. (*hne*)

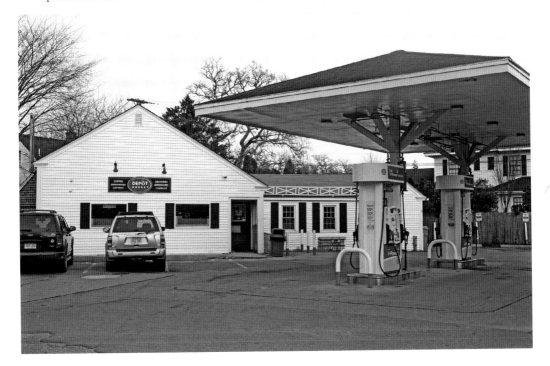

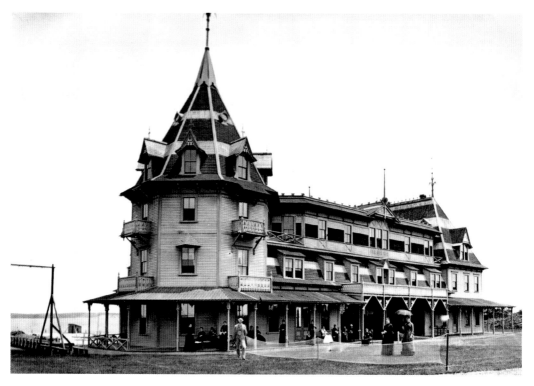

MATTAKEESET LODGE: This was the terminus of the 9-mile rail journey beginning in Cottage City. A sixty-room structure, also designed by Pratt, it opened in 1873. The rate was $10–17 a week. It was popular for clambakes, dances under the stars, and a rooftop promenade with views of Katama Bay and the Atlantic "whose constant rolling surf fascinates all beholders, and after a storm is inexpressibly grand ... the mountainous wave crests, many miles in width, topple and fall with a noise like thunder, riveting the awe struck gaze of all within sight," as an early advert proclaimed. C. 1890. (*mvm*)

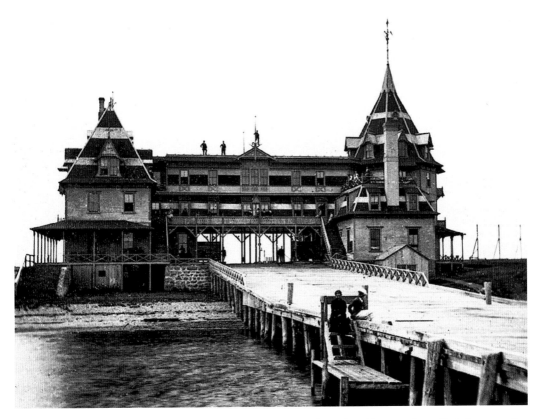

Mattakeeset Wharf: A view of Mattakeeset Lodge from the side opposite to that shown on the previous page. It cost $30,000 to build (about $700,000 in today's money) and was later sold, as business declined, to the Old Colony Railroad for $7,200. It closed in 1905 and left to vandalism until it was demolished in 1910. Despite the potential of its design, amenities, and location, it was a financial failure. Today, nothing remains of it at this site. C. 1907. (*mvm, dw*)

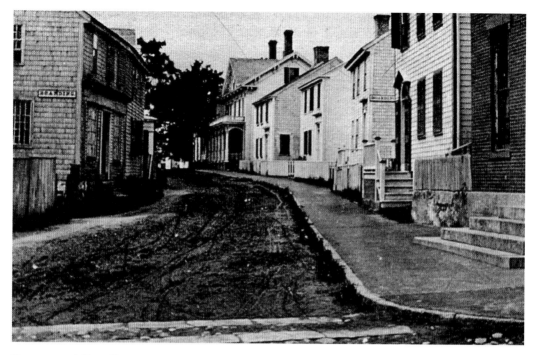

EDGARTOWN'S LATE START: An early view along South Water Street where it crosses Main Street (the noted brick bank building is at right). Edgartown may have lagged as a tourist destination but was bequeathed the distinguished homes of sea captains in the former whaling industry. As an example, at center above the arcaded building was once the home of Captain Lafeyette Rowley. It remained private until the 1930s when it became the Noëpe Lodge (Wampanoag for Martha's Vineyard). Today, it is a boutique hotel that "combines the vibe of the Caribbean with the coastal chic furnishings of New England." C. 1900. (*mvm*)

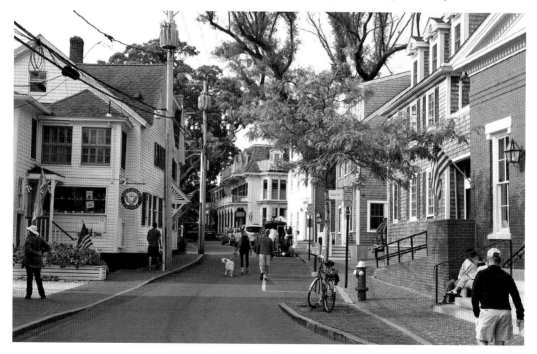

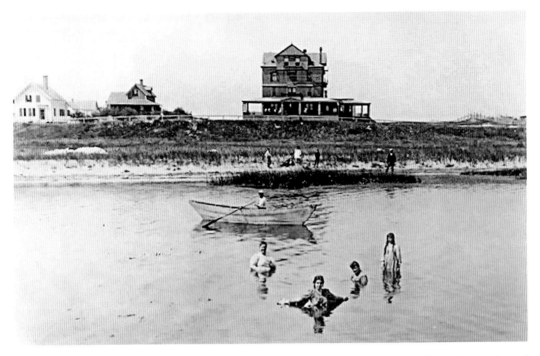

HARBOR VIEW: The Harbor View Hotel began as a roomy overgrown house without the grandeur of Cottage City's Sea View preceding it by twenty years. While Cottage City flourished as a destination, Edgartown was moribund. It had year-round inns, but no resort hotels as such until Harbor View opened in 1893, targeting "proper folk." In its first summer, the manager hosted a gala where ladies wore gowns of "cream henrietta silk" or "mahogany satin," while the hostess wore "black figured silk grenadine and Nile green cheffonne." C. 1895. (*hne*)

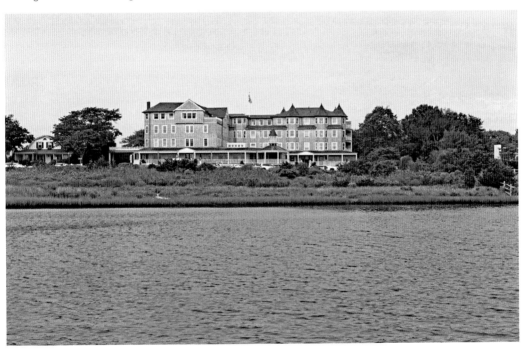

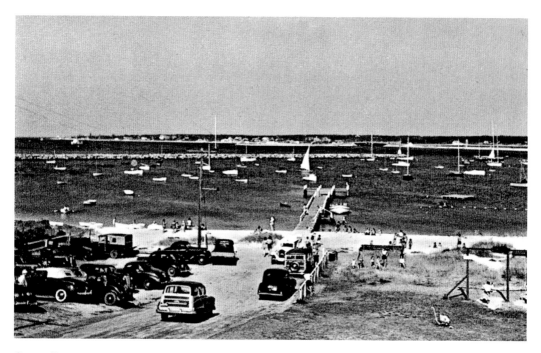

OWEN PARK: Owen Park in Vineyard Haven has long been a key public space, dock, and beach, serving Islanders and visitors alike. Linking the town to the harbor and beach, it sits on a sloping site at the transition between the commercial and residential districts. Homes originally on the site were moved by a Vineyard Haven businessman, William Barry Owen, to clear a view to the harbor from his proposed manse on William Street. This never materialized; the land was given to the town and the park opened in 1919. C. 1935. (*mvm*)

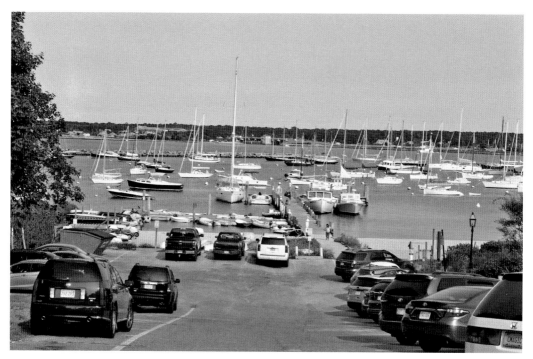

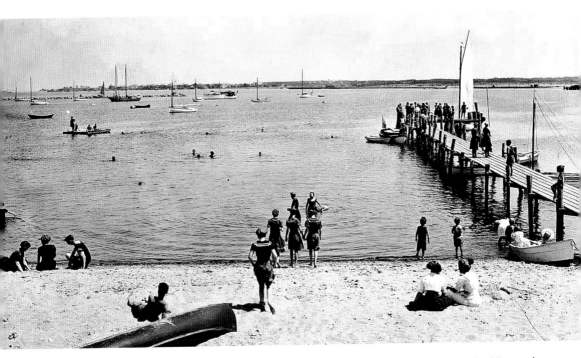

OWEN PARK DOCK: A popular spot for public mooring, Owen Park dock has been serving Vineyard Haven for a century. It remains open to the public, serving casual sailors and small fishing boats. The beach at right leads to the popular Black Dog restaurant and Steamship Authority terminal. The women's bathing costumes suggest a turn of the century date. They still wear "sailor suit" designs but, once considered too risqué, bare legs were finally permitted. C. 1900. (*mvm*)

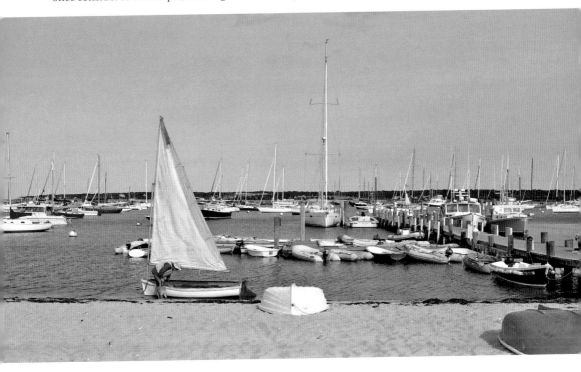

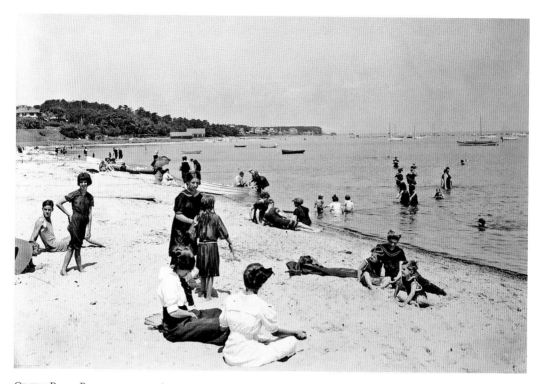

OWEN PARK BEACH: By 1900 (based on the style of the bathing costumes), the beach was established as a place of pleasure and leisure. It is scene of relaxed conversation, boating, and children wading while holding hands, yet still no blankets or beach umbrellas. These two photos show how little has changed. In other places, other circumstances, the beach of today would be likely be lined with small hotels. That it is not the case here is indicative of the island's durability. (*hne*)

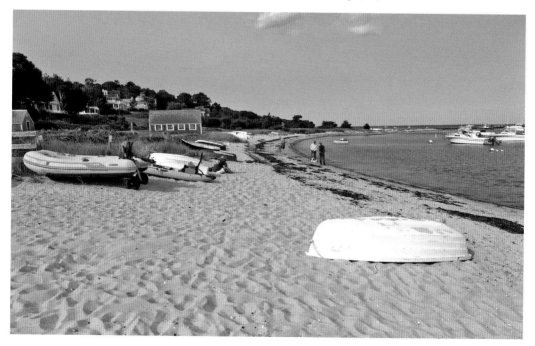

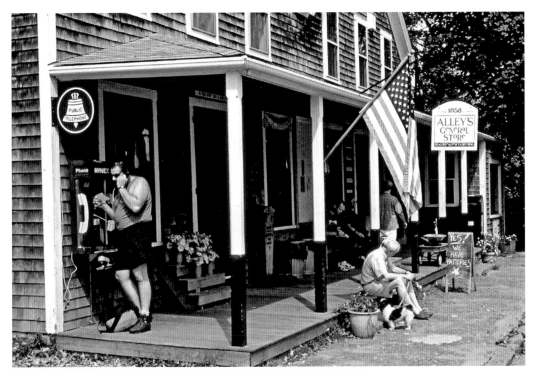

ALLEY'S: Alley's is the oldest operating retail store on Martha's Vineyard, beginning in 1858. It was established to meet the needs of Islanders themselves. Over the years, however, it has increasingly catered to the summer visitor. For anyone traveling up-island, it silently marks the journey. Due to the island-wide ban on cookie cutter franchises, its country store ambience has become ever more appreciated. It looks much the same as it always has, except for the arrival, and removal, of the pay phone. 1975. (act)

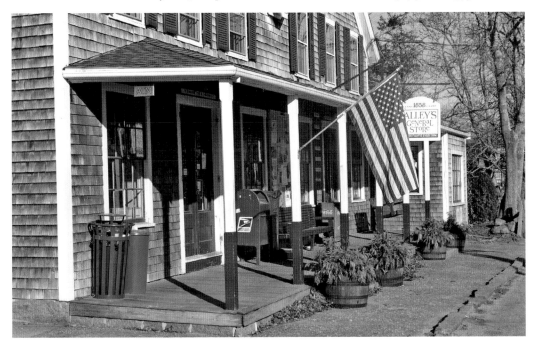

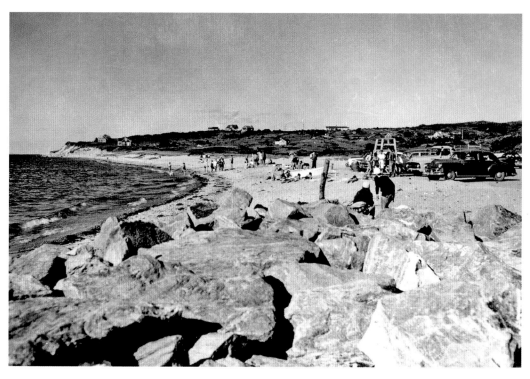

THE BEACH AT MENEMSHA: Menemsha began as small fishing community and is now also a stop on tourism's itinerary. It is still home to a small fishing fleet, charter fishing, and cruises for summer visitors. Shown here is the small public beach at the mouth of the harbor that has changed little over the decades. It is now considered the best place on the island to observe the sunset. If the air is stable and clear enough, you might even catch the optical phenomena known as the green flash. C. 1950. (*mvm*)

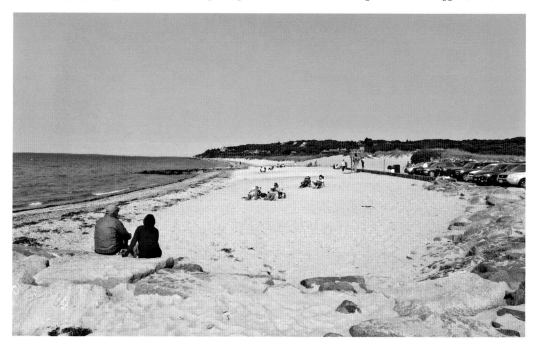

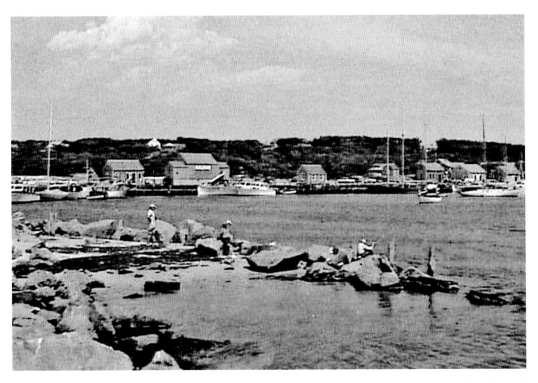

FISHING IN MENEMSHA: Menemsha began as a commercial fishing community—a place of tough work, not tourism. Its popularity as a source of fresh seafood grew, attracting increasing numbers of summer visitors to a community that became "quaint" and very expensive. Recreational fishing is enjoyed near the small public beach while pleasure boats harbor here as well as the few fishing boats that remain. C. 1950. (*mvm*)

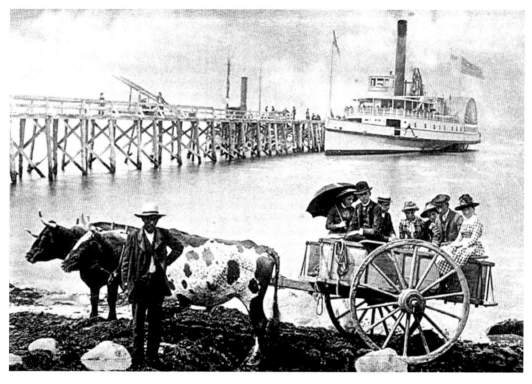

GAY HEAD WHARF: Tourism eventually reached Gay Head by boat. Although only a little over 20 miles from Oak Bluffs, the condition of the roads discouraged an overland journey and steamer excursions began in 1883. Tourists posing here in the oxcart would have used a small stepladder, out of sight here, to climb into the cart. The inset in the below image shows a portion of an early Edgerton map, indicating the wharf's approximate location. Merging this with a current aerial map provided an estimate of where the wharf was once located. C. 1890. (*mvap*)

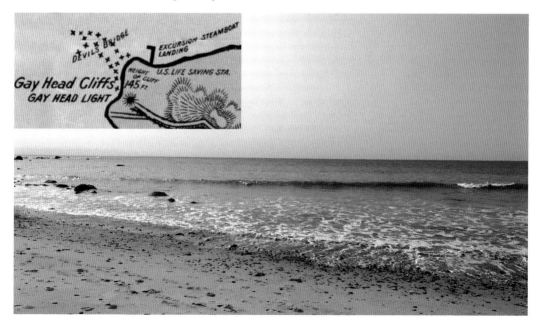

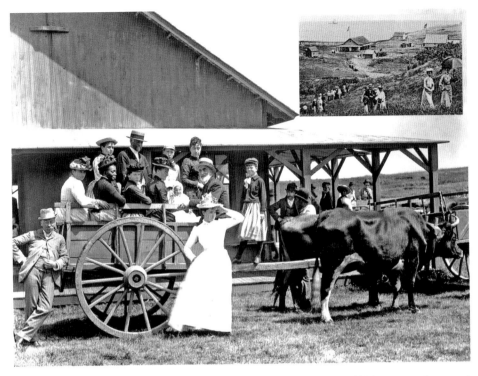

CONSUMING THE EXOTIC: Sightseers on a day's excursion to Gay Head light pose on the oxcart that brought them from the wharf to the pavilion. The inset shows the entire complex built to accommodate visitors who came to Gay Head for their grand day out. The pavilion where visitors were served lunch and enjoyed live music is at upper left. The attractions here were the Gay Head light and the clay cliffs, both features that still attract visitors. Not only does nothing remain of the pavilion complex but the land that it sat on has eroded away. C. 1890. (*mvm*)

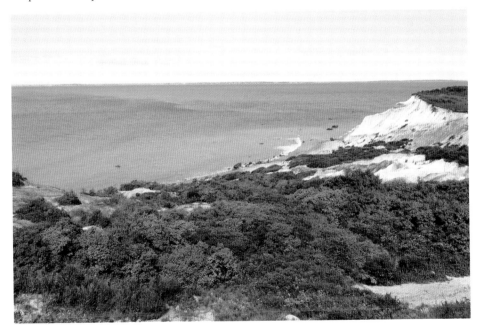

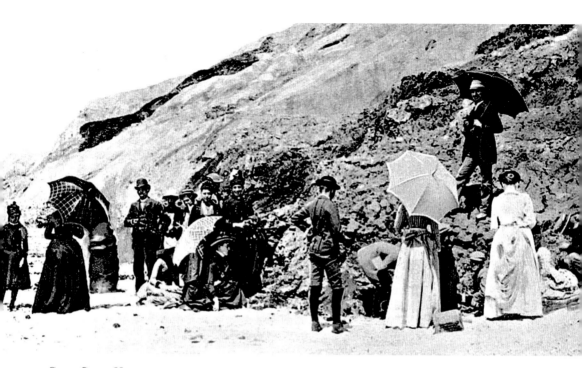

CLAY CLIFF HUNTERS: Perhaps a major difference between the visitors of today and those in the late 1800s was a prevalent interest of the latter in seashore biology. Starfish and periwinkles, dried driftwood, and ornate shells were collected and brought home to display in the parlor. Gay Head cliffs were especially studied for fossils heaved up from a much earlier geologic age. Some, it seems, still have a naked lust for them. C. 1880. (mvm)

Acknowledgments

I thank Bow Van Riper of the Martha's Vineyard Museum, Hilary Wallcox of The Vineyard Gazette, Chris Seidel of the Martha's Vineyard Commission and Donna Russo of Historic New England. Denys Wortman, the Island's premier drone pilot, provided the contemporary photos to match vintage aerial shots. William Ewen, Jr., Andrew Patch, Zoë Nugent, Bruce Wilson, the Athearn Family, Harvey Garneau, Jade Correl, Josy Chivers, David Rolanti, Horace B. Tavares, Vera Kola and Luan Lamani have each helped in their own way. Anyone who ventures upon historical research of Martha's Vineyard will, like me, receive the kind and generous support of Islanders who have a story to tell. If I have not mentioned the names of others who helped, it is not intentional. Apologies. To all named or unnamed, my warm gratitude.

Image Credits

act	*Author's Collection*
bpl	*Boston Public Library*
ck	*Courtesy, Chris Keniston*
whe	*Courtesy, Ewen Collection*
dw	*Denys Wortman*
hne	*Historic New England*
loc	*Library of Congress*
mvap	*Martha's Vineyard Antique Photos*
mvm	*Martha's Vineyard Museum*

Front cover:	top: *mvm*, bottom: the author
Back cover	top: detail, *loc*, bottom: the author

FURTHER READING

Allen, J. C., *Tails and Trails of Martha's Vineyard* (Little, Brown and Company, 1938)

Aron, C. S., *Working at Play, A History of Vacations in the United States* (Oxford University Press, 1999)

Brown, D., *Inventing New England, Regional Tourism in the Nineteenth Century* (The Smithsonian Institution, 2014)

Banks, C. and Dean, G., *The History of Martha's Vineyard Vol II Town Annals* (George H. Dean, 1911)

Corbin, Alain, *The Lure of the Sea* (University of California Press, 1994)

Denison, D. C., "Rowing to the Vineyard" (*The Boston Globe Magazine*, August 7, 1988)

Dresser, T., *A Travel History of Martha's Vineyard* (The History Press, 2019)

Ewen, W. H., Jr., *Steamboats to Martha's Vineyard and Nantucket* (Arcadia Publishing, 2015)

Foster, D., *A Meeting of Land and Sea* (Yale University Press, 2017)

Fowles, J., *Islands* (Little, Brown and Company, 1978)

Hine, C. G., *The Story of Martha's Vineyard* (Hine Bros., 1908)

Hough, H. B., *Martha's Vineyard; Summer Resort 1835–1935* (Tuttle Pub., 1936)

Hough, H. B., *Singing in the Morning and Other Essays About Martha's Vineyard* (Simon and Schuster, 1951)

Huntington, G., *An Introduction to Martha's Vineyard* (Dukes County Historical Society, 1969)

Page, H., *Rails Across Martha's Vineyard* (South Platte Press/Brueggenjohan/Rees, Inc., 2009)

Railton, A., *The History of Martha's Vineyard* (Commonwealth Editions, 2006)

Simon, P., *On the Vineyard* (Anchor Books, 1980)

Smith, W. and Stacy, B., *Island Stories* (Martha's Vineyard Museum, 2015)

Stilgoe, J. R., *Alongshore* (Yale University Press, 1994)

Weiss, E., *City in the Woods* (Northeastern University Press, 1998)